SOMERSET

Place Names

SOMERSET

Place Names

Anthony Poulton-Smith

AMBERLEY

First published 2010

Amberley Publishing
Cirencester Road, Chalford,
Stroud, Gloucestershire, GL6 8PE

www.amberley-books.com

British Library Cataloguing in Publication Data.
A catalogue record for this book is available from the British Library.

ISBN 978 1 84868 782 0

Typesetting and origination by Amberley Publishing
Printed in Great Britain

Contents

Introduction

For years, the history of England was based on the Roman occupation. In recent years, we have come to realise the influence of the Empire did not completely rewrite British history, indeed there was already a thriving culture in England well before the birth of Christ. When the Romans left our shores in the fifth century, the arrival of the Anglo-Saxons was thought to herald a time of turmoil, yet they brought the culture and language which form the basis of modern England. The same is true of our place names; the vast majority of settlement names in Somerset are derived from this Saxon or Old English language, while the topographical features, such as rivers and hills, still have names given to them by the Celts of the pre-Roman era.

Ostensibly, place names are simply descriptions of the location, its uses and the people who lived there. In the pages that follow, an examination of the origins and meanings of the names in Somerset will reveal all. Not only will we see Saxons settlements, but Celtic rivers, Roman roads and even Norman French landlords, who have all contributed, to some degree, to the evolution of the names we are otherwise so familiar with.

Not only are the basic names discussed but also districts, hills, streams, fields, roads, lanes, streets and public houses. Road and street names are normally of more recent derivation, named after those who played a significant role in the development of a town or revealing what existed in the village before the developers moved in. The benefactors who provided housing and employment in the eighteenth and nineteenth centuries are often forgotten, yet their names live on in the name found on the sign at the end of the street and often have a story to tell. Pub names are almost a language of their own. Again, they are not named arbitrarily but are based on the history of the place and can open a new window on the history of our towns and villages.

Defining place names of all varieties can give an insight into history which would otherwise be ignored or even lost. In the ensuing pages, we shall examine 2,000-plus years of Somerset history. While driving around this area, the author was delighted by the quintessentially English place names around the area and so, having already taken a look at *Oxfordshire Place Names, Hampshire Place Names, Gloucestershire Place Names, North Devon Place Names, South Devon Place Names* and *Dorset Place Names*, turned to Somerset. This book is the result of the author's long interest in place names which has developed over many years and is the latest in a series which continues to intrigue and surprise.

To all who helped in my research, from the librarians who produced the written word to those who pointed a lost traveller in the right direction, a big thank you.

Abbas Combe–Axe

ABBAS COMBE

Listed as simply Cumbe in 1086 and Coumbe Abbatisse in 1327, the basic name is from Old English *cumbe*, a term found in the South West for 'valley'. Here, the addition comes from Latin *abbatisse* and refers to 'the valley of the abbess', a reference to the early possession by Shaftesbury Abbey.

ABBOTS LEIGH

From Old English *leah* and meaning the '(place at) the woodland clearing', this name is recorded as Lege in 1086. The addition here refers to its possession by the abbot of St Augustine's in Bristol.

AISHOLT

Found as Aescholt in Domesday, when it was held by Roger de Courseulles, this name comes from Old English *aesc holt* and tells us it was the '(place at) the ash tree wood'.

ALFORD

A name recorded in Domesday as Aldedeford and which is a Saxon place name telling of 'the ford of a woman called Ealdgyth'.

ALHAMPTON

Recorded as Alentona in Domesday, this name means 'the farmstead on the River Alham'. Here are two elements, the Old English *tun* meaning 'farmstead' following a Celtic river name of unknown origins. The local pub is simply known as the Alhampton Arms.

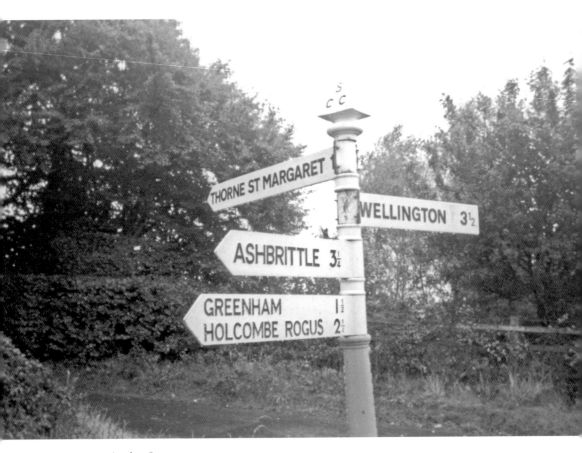

Fingerpost near Appley, Somerset

ALLER

First found at the end of the ninth century as Alre, this is exactly how it is found in Domesday two centuries later. This comes from the Old English *alor* meaning '(place at) the alder trees'. On the opposite bank of the river is the deserted village of Oath, today only seen in the name of Oath Lock, the upper tidal limit of the river. Records of this name are limited, but it might well be a corruption of *ac* or 'oak trees'.

The local in Aller is the Old Pound Inn, which was built (as seems evident) on the site of the old pound, where stray livestock were kept awaiting collection by their owners, who had to pay a fine before they could recover their property.

ALLERFORD

A name not unlike the previous example, for it comes from the same word, but this time also with Old English *ford*. This '(place at) the ford by the alder trees' is recorded as Alresford in Domesday.

ANGERSLEIGH

Found as Lega in 1086 and Aungerlegh in 1354, this name comes from Old English *leah*, most often seen as a suffix meaning 'the woodland clearing'. Here, the name has a second element which has been seen since the fourteenth century and which refers to the Aunger family, lords of this manor from at least the thirteenth century.

ANSFORD

Found in Domesday as Almundesford, this name comes from the Old English language and describes 'the place at the ford associated with Ealhmund'.

ASH

A small village which derives its name from Old English *aesc* or 'the place at or by the ash trees'. The local pub shows the long-time association between the pub and the church, these being the only two regular meeting places for a community more spread than today with everyone working the fields. Thus we see many pubs named the Bell Inn, which was also an easily recognised symbol.

ASHBRITTLE

As with the previous name, this is from Old English *aesc*, '(place at) the ash trees'. Recorded as Aisse in Domesday, the addition is first seen in 1212 as Esse Britel, the manorial affix from its possession by a man called Bretel, who is first named in 1086 in the Domesday record.

ASHCOTT

The only record of note here is Domesday's Aissecote, which comes from Old English *aesc cot*, telling us of 'the cottages where the ash trees grow'.

Here we find Berhill, a name from *beorg hyll* and meaning 'the mound or tumulus on the hill', and Buscott is 'the cottages by the bushes'. Public houses here show the close relationship between the pub and the church in the name of the Ring o' Bells, while the Pipers Inn is named after the Highland troops sent by the King to quell the Monmouth Rebellion and the sign displays the image of a Scots piper.

ASHILL

Another name derived from the Old English *aesc*, here with the addition of *hyll* and listed as Aiselle in Domesday. This name tells us the settlement began life 'at the hill where the ash trees grow'.

A local pub here is the Square & Compass, imagery which is a reference to the basic tools used by various skilled workers such as carpenters, joiners and stonemasons.

ASH PRIORS

A simple name which is recorded as Aesce in 1065, a name which comes from Old English *aesc* meaning '(place at) the ash trees'. In 1263, there is documented evidence of this place as Esse Prior, the addition showing possession by the Prior of Taunton.

ASHWICK

From Old English *aesc-wic* comes 'the farmstead where ash trees grow', a name recorded as Escewiche in 1086.

ATHELNEY

Two records of this name of note, as Aethelingaeigge in 878 and as Adelingi in 1086 as part of the Domesday survey. This is undoubtedly the Old English *atheling-eg*, which refers quite literally to 'island of the princes'. However, this is not telling us it was a training school for the heirs to the throne, indeed it is not even telling us it was surrounded by water. To the Saxons, any male child of a prosperous family was a prince, while the 'island' was more often the dry ground in a predominantly marshy terrain.

AXBRIDGE

In the tenth century, this name was recorded as Axanbrycg, a name which features a Celtic river name and an Old English *brycg*. Together, it speaks of the '(place at) the bridge over the River Axe'. This river name is of Celtic origins and discussed under its own entry.

Public house names here reflect three of the most common themes. The Oak House Hotel is a reminder of how often large or prominent trees were used as markers; the Crown is a 600-year-old statement of royalist support; and the Lamb Hotel is named after the Lamb Brewery, which was established in Somerset.

AXE (RIVER)

A river name found in a document from 712 as Aesce and earlier still from 693 as Axam, this name is much older, coming from a Celtic word meaning simply 'water'.

Chapter 2

Babcary–Butleigh

BABCARY

Listed as Babba Cari in Domesday, this is undoubtedly the 'estate on the River Cary held by a man called Babba'. This Celtic river name is discussed under its own entry.

BACKWELL

From the Old English *baec wella*, this is 'the spring or stream near a ridge', and is recorded as Bacoile in 1086 and Bacwell in 1202.

BADGWORTH

Domesday records this place as Bagewerre, which comes from 'the enclosure of a man called Baecga' and is derived from a Saxon personal name and the Old English *worth*.

BAGBOROUGH

Records of this name start in 904 as Bacanbeorg and as Bageberge in 1086. Here is 'the hill of a man called Bacga' with a Saxon personal name followed by *beorg*.

BALTONSBOROUGH

Here, the Saxon personal name is followed by the Old English *beorg*, which brings us 'the hill or mound of a man called Bealdhun' and is listed in 744 as Balteresberghe and in 1086 as Baltunesberge.

BANWELL

A name found as Bananwylle in 904 and as Benwelle in 1086, this is from Old English *bana wella*. Here, the '(place at) the spring or stream of the killer' needs a little consideration. The most obvious explanation is this is where someone lost their life, and yet this does not fit the normal evolution of place names. Names evolve over a

period of time and, while there are examples, names from a single moment in history are rare and usually refer to much more significant events than this. Hence the more rational explanation that this was a warning, a stream where the water was unfit for consumption, thought to be poisonous.

One local pub is the Whistling Duck, the winning entry in the local newspaper's competition to name the pub organised in 1967. This is an alternative name for the coot, held to be actively sought out by other wildfowl, for their warning cry would alert them to the danger from predators.

BARLE (RIVER)

Rising on Exmoor some 1,300 feet above sea level, this river flows just seven miles to join the River Exe. The name is recorded as Bergel in 1219 and as Burewelle in 1279 and comes from Old English *beorg wella* or 'the hill stream', a quite fitting description.

Along the Barle Valley, the most impressive feature is the Tarr Steps clapper bridge, thought to be around 3,000 years old. The bridge is a collection of stone slabs weighing up to five tons each; together, the seventeen spans cross 180 feet of river and bank and are a Grade I listed bulding. Legend has it that the bridge was the work of the Devil, who swore to take the life of anyone who dared to cross it. Fearful for their lives, the locals appealed to their parson, who sent his cat across to test the waters, as it were. The cat vanished in a puff of smoke, so the parson crossed to halfway to confront the Devil, who tried everything he could to intimidate the man. However, he gave back as much as was hurled at him and the Devil finally relented and agreed to allow the villagers to pass in safety. He insisted he retain the rights to sunbathe on the bridge and, should he be working on his tan, the villagers should stay away lest he send them from this world in the same way as he had the cat.

BARRINGTON

Found in Domesday as Barintone, where a Saxon personal name is followed by Old English *ing-tun*, this name describes 'the farmstead associated with a man called Bara'.

BARROW GURNAY

Listings of this name include Barwe Gurnay in 1283, which confirms that this common place name is derived from Old English *bearu*, meaning 'the wood or grove'. The addition, which is to be expected with so common a first element, is manorial and a reference to it being held by Nigel de Gurnai in the late eleventh century.

BARROW (NORTH AND SOUTH)

As with the previous name, this is the '(place at) the grove' and these are recorded as Berue and Berrowene in Domesday. The two places, having obvious additions, are less than a mile apart.

BARTON ST DAVID

Listed as Bertone in 1086, this Domesday entry is sufficient to see this as coming from Old English *bere tun* of 'the barley farmstead', with the later addition of the dedication of the church.

BARWICK

Coming from Old English *bere wic* and listed as Berewyk in 1219, this name refers to 'the barley farm'.

BATCOMBE

Here, 'the valley of a man called Bata' sees the personal name followed by Old English *cumb*, a common suffix in the south-west of England. The place is recorded as Batancumbe in the tenth century and as Batecumbe in Domesday. There is also the small hamlet of Westcombe, simply 'the western place in the valley'.

BATH

Found as Bathum in 796 and Bade in 1086, this is predictably the '(place at) the baths' and, of course, a reference to the famous Roman baths, which still stand today.

Pubs around bath also tell of the history of the town.

While the Bear might be associated with the barbaric sport of bear-baiting, more often it is simply heraldic and found in the coats of arms of numerous families. The Wheatsheaf is a symbol found in the coat of arms of the Brewers' Company, a theme also seen in the name of the Barley Mow. The Golden Fleece was adopted as the symbol by the Knights of the Golden Fleece, a chivalric order founded in 1429 to protect the church. The Ram appears in the arms of the Worshipful Company of Clothworkers and other trades associated with the woollen industry.

The Pig & Fiddle is a unique variation on 'pig and whistle', which began life as a generic name for the crew bar on board a merchant ship and has since been transferred to land. The Boater refers to the straw hat worn by men, the name coming from these being worn while boating. The Devonshire is a reference to the stagecoach of this name, which operated a regular service between Taunton and Salisbury. The Porter is a different way of commemorating the railway, while also remembering that the mail-sorting office was nearby, thus encouraging trade from both places. The Pulteney Arms is named after the William Pulteney, 1st Earl of Bath (1684-1764).

The Curfew refers to that operated in the town during the Civil War; the original curfew was a bell, rung in the evening to warn that all fires should be extinguished.

The Livingstone Hotel was named after David Livingstone (1813-73), Scottish missionary and explorer who travelled the then largely unknown African continent and named Victoria Falls in honour of the reigning monarch. He is probably best remembered for something attributed to him but which was quite obviously spoken by another. When no

news had been heard of Livingstone for a considerable time, an American newspaperman, Henry Morton Stanley, was sent by the *New York Times* to search for him. He eventually reached him and greeted him with the now-famous words 'Dr Livingstone, I presume?'

The district of Walcote takes its name from Old English *walh cote* referring to 'the cottage of the Welsh'. However, it should be noted that, to the Saxons at least, *walh* simply meant 'foreigner', and although this almost certainly refers to British or Celtic individuals, there is always a small chance the occupants were from further afield.

When thinking of Bath and food, the obvious connection is the Bath bun. However, there is also the Sally Lunn bun, which is still produced to the original recipe on the original premises. This traditional yeast bun is thought to have been brought to England in 1680, a time when the Protestant Huguenots were forced out of Catholic France and came to England bringing with them a range of skills and talents. One of these was Solange (Sollie) Luyon, who brought her recipe, which became a firm favourite with the Georgians as it complements both sweet and savoury tastes equally well. It is not clear when the name became corrupted, but both premises and produce have certainly been known by the Anglicised version for as long as records have survived.

BATHAMPTON

As seen in the early records of Hamtun in 956 and Hantone in 1086, this place was historically known simply by the Old English *ham-tun* or 'the home farm'. This is a common place name and we would expect to find a second element following this for distinction. However, here the addition precedes the basic name, a reference to nearby Bath.

BATHEALTON

Listed as Badeheltone in Domesday, this name features a Saxon personal name. Such are common in place names and often the most common record of a personal name we are likely to find. Thus it is difficult to be certain if the name is exactly right. For example, even if we were aware of the name Michael and its female equivalent, without ever knowing of the pet forms, how would we recognise Mick, Mike, Mikey, Mickey, Mitch, Michaela, Michelle, Chelle, or Shelley as in any way related? Thus, while this is probably 'Beaduhelm's *tun* or farmstead', there will always be an element of doubt. Yet it is certain that it does not have any association with the town of Bath, as is the case with the preceding names and those which follow.

BATHEASTON

A name found as simply Estone in Domesday has become Batheneston by 1258. Here, Old English *east tun* speaks of 'the eastern farmstead', clearly named by a settlement to the west and possibly founded by some of its former inhabitants. The addition is simply a reference to its close proximity to the town of Bath.

Before goods were transported by road, rail and canal, the largest loads were taken overland by cart. While the sign invariably depicts a load of hay, in truth, the pub sign

of the Waggon & Horses represents all manner of items transported around the country, not over long distances but between agents, that is, the pubs. Incidentally, the spelling 'waggon', rather than the modern 'wagon', is correct, for even the *Oxford English Dictionary* still gives this as the British spelling.

BATHFORD

From Old English *ford*, this place name is recorded as Forda in 957 and Forde in 1086. This speaks of the '(place at) the ford', a name which later saw the addition of the nearby town of Bath from at least 1575 as Bathford.

The local here is the Crown, a pub name which shows support for both the monarchy and the nation.

BAWDRIP

This name has been somewhat corrupted by time, indeed, it is listed as Bagetrepe in Domesday, which is much closer to the original Old English *bagga trappe*. This place name tells us it was 'the place where badgers are trapped', presumably for their skins, and is a name which can still be recognised in the tongue of the Saxons.

Here is the small hamlet of Bradney, a name found as Bredeneia in Domesday, as Bradenye in 1243 and as Bradeneye in 1324, a name referring to 'the broad island' from Old English *brad eg*. The local pub also takes the name of a feature in the landscape: the Knowle Inn is derived from *cnoll*, meaning 'a small rounded hill.

BECKINGTON

Domesday records this as Bechintone in 1086. Here the Saxon personal name, together with Old English *ing tun*, tells us this was 'the farmstead associated with a man called Becca'.

Public houses here include the Woolpack, a name which refers to the standardised bale of wool weighing 240 pounds, and a time when the wealth of the nation was built on its wool trade.

Standerwick is a hamlet in this parish recorded as Stalrewiche in Domesday and as Stanrewic in 1231. This comes from Old English *staen wic* 'the specialised farm on stony soil', where the *wic* is probably referring to a dairy farm but we cannot be certain.

BEER CROCOMBE

Early records of this place name are restricted to Domesday's Bere in 1086. This, considering the unreliability of the proper names in the great census, is insufficient for us to decide if this is Old English *bearu*, 'the grove', or *baer*, 'the woodland pasture'. What we can be sure of is the basis for the addition, which refers to its manorial holding by the Craucombe family, who were here by the thirteenth century.

BELLUTON

A name recorded as Belgetona in Domesday, which comes from Old English *Belgae tun* or 'the farmstead associated with the Belgae tribe'.

BERKLEY

While Domesday may be unreliable when it comes to proper names, as long as it is understood that the Norman French surveyors will see a word from a certain phonetic viewpoint which differs from that of the Saxon speakers, it is still a useful source of information providing the French accent can be seen in the record. This is one such example, where the record from 1086 of Berchelei can be seen as simply the French pronunciation of the Old English *beorc leah*, describing the '(place at) the birch tree clearing'.

BERROW

Without the records of Burgh in 973 and Berges in 1196, this may well be mistaken for a corruption of the common place name of Barrow. However, this comes from Old English *bearu* meaning 'grove' and is completely different from the true origin of *beorg*, describing the '(place at) the hills or mounds'. A look around will show this to be a rather flat part of the county, however, even the smallest gradient in a predominantly flat landscape is described as a hill and here it refers to the sand dunes.

BICKENHALL

A name found in 1086 as Bichehalle takes the form of a Saxon personal name with Old English *heall* and describes 'the hall of a man called Bica'.

BICKNOLLER

A name not found before 1291 when it appears as Bykenalre. Here, the Saxon personal name has a genitive 'n', a grammatical feature more often associated with American English today, with Old English *alor*, telling us this was 'the alder tree(s) of a man called Bica'.

BIDDISHAM

This name has changed little since it was first seen as Biddesham in 1065. Here, the name of the Saxon individual is followed by Old English *ham* or *hamm*, telling us it was 'Biddi's homestead or water meadow'.

Here locals can enjoy a drink at the New Moon Inn, the moon being a simple image, easily recognised, and suggesting a meeting place after nightfall. The addition of 'new' more likely refers to the building rather than that phase of the moon, the new moon

being unlit when viewed from the Earth and thus a very poor subject. Whether this suggests the pub replaced an earlier example, or simply underwent a refit or a new owner, is unclear.

BINEGAR

Defining some place names relies on knowledge gleaned from similar examples elsewhere. When, as is the case here, the name is distinctly different and early forms are restricted to just one example, this makes definition uncertain. Here, the record of Begenhangra in 1065 has two possible meanings, either this is Old English *begen-hangru* and 'the wooded slope where berries grow', or the first element is a personal name and gives 'the wooded slope of a woman called Beage'. Without further examples, the true origin will remain uncertain.

BISHOP'S HULL

Found as Hylle in 1033, as Hilla in 1086, and Hulle Episcopi in 1327, this is Old English *hyll* with a Latin reference to 'the place at the hill owned by the Bishops of Winchester'.

BISHOP SUTTON

Here is a name coming from Old English *suth tun* and telling us it was 'the southern farmstead', with the addition to this common place name showing possession by the the bishopric.

BLACKFORD

No surprises with this place name referring to 'the dark ford'. It comes from Old English *blaec ford* and is recorded as Blacford in 1227. This is a common combination and is understood in a number of ways: dark waters, rich dark loam soil, high sides or thick vegetation blocking sunlight – any one or more may contribute to the 'dark ford'.

The local here is the Sexeys Arms Inn, the family which included Hugh Sexey. In 1599, this man was appointed royal auditor to Elizabeth I and continued to serve under James I. Sexey's Hospital was built in Bruton in 1619 from the proceeds in his will, eventually becoming a boarding school in 1899. The surname comes from one of two places in north-eastern France.

BLAGDON

There are actually two places of this name in Somerset, one recorded as Blachedone in 1086, the other as Blakedona in the twelfth century. These names share a first element with the previous name and come from Old English *blaec-dun* or 'the dark-coloured hill'.

BLEADON

Recorded as Bleodun in 956 and Bledone in Domesday, this name is derived from the Old English *bleo-dun* or 'the variegated hill'. This term, rarely used today other than to describe the plant where the main body of a leaf is distinctly different from the other edge which is most often lighter in colour, is applied exactly the same to the hill. From the view afforded of the hill to those in the settlement, the hill would have appeared to have had two colours, either because of a change in soil textures or vegetation, or a combination of the two.

BLUE ANCHOR

A small resort which took its name from the seventeenth-century inn; a pub of this name still exists here. The anchor clearly symbolises the sea or seafaring, while the colour blue represents hope. Perhaps another clue as to the growth of the coastal village is given by the other pub here, the Smugglers. The village is one end of the coastal area of Special Scientific Interest; from here east to Lilstock, the area provides a remarkable selection of fossils.

BOWLISH

A small hamlet with a name derived from *boga laes* and describing 'the bow-shaped pasture'. Here are two further names of note: the Horseshoe Inn which was formerly the site of the village blacksmith, hence the name; and Ham Lane, said to have been named to remember the Butcher's Arms which closed in 1860.

BRADFORD ON TONE

Bradford is a common place name and always refers to 'the broad ford'. Such names invariably have a second defining element, here it is the River Tone meaning 'the roaring one' and a name discussed under its own entry.

BRATTON SEYMOUR

Since this place was recorded as Broctune in 1086, the basic name here has undergone some change. This early record shows it to be from Old English *broc tun* or 'the farmstead by the brook'. To find the modern form of Bratton is unusual; clearly this would be a very common name and such is found as Brocton or Brockton throughout England. Because it is so common, the addition is expected and here refers to the manorial holding by the Saint Maur family, who were here around 1400. This also shows that, despite a lack of forms from this period, that the corruption must have occurred after this date. Additions are for distinction and there are no other Brattons nearby and thus it must have still been a Brocton at this time.

BREAN

Today, the name of Brean is associated with the resort. However, this is strictly speaking Brean Sands, itself named after the original, which is a visible inland and found as Brien in 1086. Here, the name most likely comes from the Celtic *brez* or 'hill'.

Pubs here reflect this coastal location in names such as the Seagull Inn and the Beachcomber Inn, and there is indeed a great deal of beach to comb!

BRENT

Here is another Celtic name, recorded in 663 as Brente and as Brentemerse in 1086. The basis for the name is unknown but is thought to be derived from a word related to the *brez* seen in the previous name of Brean. Here, the term is understood to mean 'the high place', although Domesday includes a second element, Old English *merse* or 'marsh'.

BRENT KNOLL

This is also known as South Brent, showing its location in relation to the previous place name. Here the origins are identical; this is an unknown term describing 'the high place', although this example has a second element which means ostensibly the same thing. The Saxons, not understanding the Celtic name, added Old English *cnoll* or 'hill top'. There is also an East Brent here too. The name of Edingworth is found as Lodenwrde and Iodena Wirda in Domesday, as Hedeneworth in 1234, and as Edenworth and Edenwrthy in 1274, which seems to be from *eow denn worth* or 'the enclosure by the pasture for ewes'.

The local is the Red Cow, which seems to have started as simple imagery and has no etymological value at all.

BREWHAM

Found as Briweham in 1086, this Domesday record shows this to be 'the ham or homestead on the River Brue'. This is a Celtic river name meaning 'brisk', and describing the flow of this water course.

BRIDGWATER

A name which, not surprisingly, is seen as 'the bridge over the water' and where one 'e' has been lost over the centuries. The missing vowel is correct but the definition is not. The record from Domesday gives this place as Brugie, while a century later, in 1194, this has become Bridgewaltier. This twelfth-century example is significant, for it shows that the second part cannot be 'water', for this is never seen in forms this early. The true origin here is 'the place at the bridge held by a man called Walter', with the suffix and early name coming from Old English *brycg*. While this individual is not known or recorded, it was a popular name at the time and is undoubtedly the basis for the place name.

Robert Blake silhouetted against the sunset in Bridgewater

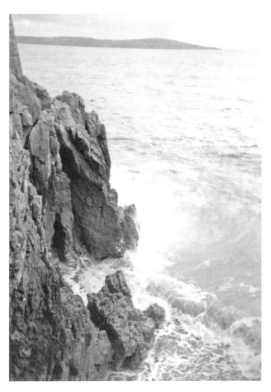

A murky and windy Bristol Channel

Locally, we find Barclay Street, named after the Barclay Arms Inn. Castle Bailey takes the name of the medieval castle, as does Castle Street (but the town moat and Moat Lane are no more). Yet the latter was earlier known as Chandos Street and what is now Chandos Street was once Little Chandos Street and the two remember the family name of the Duke of Buckingham, who funded these developments.

Eastover was recorded as Estovre in 1323, a name describing 'the eastern bank of land'. Horse Pond was where these animals were taken for centuries to be watered in Durleigh Brook. Friarn Street and Friarn Avenue are named after the Franciscan Friary which was founded here in the thirteenth century.

Other pubs here include the Cross Rifles, acknowledging the formation of the local Rifle Volunteer Force in 1859. The Great Escape may conjure up images of the film of that name, but it is used here as a message of invitation to get away from it all for a while; similarly, the Bunch of Grapes advertises the product on sale within. The Bristol & Exeter remembers the railway line which served these places and which was opened in 1840.

Patriotic names include the Rose & Crown, the Three Lions, the British Flag, and the King Alfred Inn which remembers the man who united the English against the Danes. The Green Dragon shows this was associated with the holdings of the earls of Pembroke, while the Quantock Inn refers to the hills of that name to the north and which are defined under their own name.

The Parrett Inn overlooks the River Parrett across Salmon Parade, for this was where these coveted food fish were brought. High Street is only above the remaining roads in importance and stature, not elevation. St Mary Street is overlooked by the church which gave it a name. Dampiet Street was listed as Damyet Street five centuries ago, which shows it featured a raised area to help prevent flooding. Penel Orlieu is an unusual street name, with an even more unusual evolution, for it comes from two former streets, Pynel Street and Orliue Street which, in turn, are named from former residents.

Of course, one of the town's best-known sons is remembered by Blake Street. Robert Blake was born in Bridgwater in August 1598; the eldest of twelve sons, he was educated before carrying on his father business. Blake's first forty years are quite unremarkable, indeed surprisingly so considering what he achieved afterwards. In 1640, he entered parliament, representing his home town. During the Civil War, he served under Popham, securing decisive victories against Prince Maurice at Lyme in 1644, followed by a major turning point in the war with victory at Taunton after a battle which lasted a year. In 1649, he was given command of the fleet, winning naval engagements against isolated Royalist strongholds in Scilly and Jersey, defeated the Dutch, routed pirates in Tunis and Algiers, and virtually eliminated the Spanish at Santa Cruz. It was when returning from that final victory, on 7 August 1657 and in sight of Plymouth Harbour, that Admiral Robert Blake died.

BRISTOL CHANNEL

Clearly this takes its name from the largest port and, while the city is not a part of Somerset, it needs to be defined.

The earliest records of Bristol date from the eleventh century, as Brycg stowe before the arrival of the Normans, and as Bristou in the Domesday record, which had been

ordered by William the Conqueror in Gloucester Cathedral on Christmas Day 1085. This name comes from the Old English *brycg stow* and refers to 'the assembly place by the bridge'.

BROADWAY

From Old English *brad weg*, this is 'the broad way or road' and is recorded as Brudewei in 1086.

The minor name of Hare is not well documented but is thought to be from Old English *har*, meaning 'grey' and often used to describe a boundary stone.

BROCKLEY

With early forms restricted to Brochelle in Domesday, it is not clear if this is Old English *brocc leah*, or 'the woodland clearing frequented by badgers', or if the first element is a personal name, giving 'Broca's woodland clearing'.

BROMPTON RALPH

One of two Bromptons here, this place is found as Burnetone in 1086 and Brompton Radulphi in 1274. This is an Old English Bruna, the Saxon name for the Brendon Hills, with *tun* and meaning 'the farmstead by the brown hill'. The addition is manorial and refers to it being one of the possessions of a man called Ralph.

BROMPTON REGIS

The second Brompton or 'farmstead by the brown hill', is described as being 'the king's land'. The place is recorded as Brunetone in 1086 and Brompton Regis in 1291.

Locally, we find the name of Bury, from Old English *burg* and referring to 'a fortified place'.

BROOMFIELD

From Old English *brom-feld* or 'the open land where broom trees grow', this place is found in Domesday as Brunfelle. The Saxon term 'feld' is recognisable as being similar to modern 'field', yet they are not exactly the same thing. A 'feld' was a region cleared of trees and undergrowth to provide grazing areas for livestock. There were no hedge borders or fences, any boundaries were purely natural and simply formed from the uncleared vegetation – unlike the modern field.

BRUSHFORD

Domesday's record of Brigeford shows the name had not been corrupted by the end of the eleventh century but is a much more modern development. This comes from Old English *brycg-ford* or 'the ford by a bridge'.

BRUTON

A Celtic river name meaning 'the brisk one' is here suffixed by Old English *tun* and refers to 'the farmstead on the River Brue'.

The local is the Blue Ball Inn, here a name of heraldic origins and pointing to the Courtenay family, earls of Devon. This is indeed an ancient dynasty, tracable back to the Castle of Courtenay and Athon in the tenth century, from there back to the Count of Sens, and further back still to Pharamond (sometimes Faramund), a king of the Franks who is reputed to have founded the French monarchy in AD 420.

BRYMPTON

Another name which has been corrupted since the original Old English *brom tun* or 'the farmstead where broom grows'. This is further evidenced by the early forms of Brunetone in 1086, Brimpton in 1264 and Bromton in 1331.

Alvington is a hamlet in this parish which is recorded as Alwintone in 1221 and as Alfinton in 1228. This comes from a Saxon personal name and Old English *ing tun* and speaks of 'the farmstead associated with a woman called Aelfwynn', which should be noted as being the name of a woman.

The hamlet of Lufton here is recorded as Lochetone in 1086, as Luketun in 1227, and as Luketon in 1340, a name which features a Saxon personal name and Old English *tun* and speaks of 'the farmstead of a man called Luca'.

BUCKLAND DINHAM

This is a common name from Old English *boc land*, 'the charter land' and a reference to special privileges granted by an Anglo-Saxon charter. Here, the name is suffixed by the name of the de Dinan family, here by the thirteenth century. Records have been discovered showing this to be Boclande in 951 and Bochelande in 1086.

BUCKLAND ST MARY

As with the previous name, this comes from Old English *boc land* and tells us it was 'the charter land'. Here, the distinctive addition comes from the dedication of the church.

Folklore tells of how this village was the site of the final battle between the Pixies and the Fairies. The Pixies won and banished their enemies forever, while the victors still visit the village.

BURCOTT

Listed as Burcotan in 1065 and as Burecote in 1243, this name is derived from Old English *burg cot*, which refers to 'the cottages of or by the fortified place'.

BURNETT

Domesday shows this name as Bernet, itself a Norman French approximation of Old English *baernet* or 'the land cleared by burning'. Such clearings must have been quite common and perhaps evidence of this still remained and thus was comparatively recent.

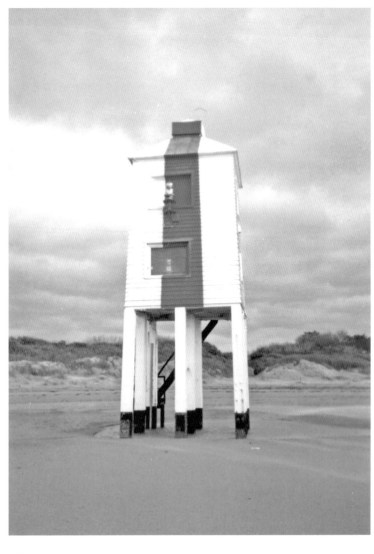

The unique wooden lighthouse at Burnham-on-Sea.

BURNHAM ON SEA

Here is a name with an expected etymology, with records of Burnham in 880 and Burneham in 1086. This is from Old English *burna hamm* or 'the river meadow of or by the stream'.

The additional 'on sea' is self-explanatory and was likely added to offer a promise of a holiday by the sea. However, the tides around this mud flat can recede for over a mile and a half. One thing these early holidaymakers will have seen is the pier; built for their enjoyment, it still ranks as the shortest in the land, and is another reminder of the dangerous mud flats, for without a solid base, there could be no pier. The place gave its name to the Old Pier Inn nearby.

Other pubs here include the Lighthouse Inn, which remembers the beacon guiding mariners into the River Parrett and on to Highbridge and Bridgwater. The Somerset & Dorset Inn remembers that branch of the Great Western Railway opened in 1858; similarly, the Railway Inn is a common name found near a station.

In the resort is Ben Travers Way, the playwright having lived here. Travers is renowned for writing the series of farces which were put on at the Aldwych Theatre, although he did write other plays, five novels, two autobiographies and a book reminiscing on his and others' cricketing experiences. Farce on stage relies on split-second timing and is very much slapstick comedy. In order for these to transfer to other media forms, Travers rewrote the plays at the age of eighty-three. Later, at the age of ninety, he had written his comeback for the stage, another farce. When asked how he could justify writing sex romps at his age, he responded with 'I have an awfully good memory'. There is also an Aldwych Close, remembering the theatre in which his plays were performed.

Other playwrights are remembered in the roads running off Ben Travers Way: Shaw Path is after George Bernard Shaw; Stoppard Road is after Tom Stoppard; Noel Coward Close is named after the man who was also an actor and songwriter; Barrie Way recalls the man who wrote *Peter Pan* and *The Admirable Crichton*; Sheridan Road recalls the Irish playwright Richard Brinsley Sheridan; Oscar Wilde is remembered by Wilde Close; John Boynton Priestley gave his name to Priestley Way; Alan Ayckbourn is marked by Ayckbourn Close; Pinter Close is named for Harold Pinter; John James Osborne is remembered by Osborne Walk; Olivier Close could be named after the Olivier Theatre, but ultimately refers to Laurence Olivier; Cookson Close refers to Catherine Cookson, a novelist whose works have been dramatised for television; and Archer Drive can only refer to Jeffrey Archer, who moved to nearby Weston-super-Mare when just two weeks old.

As this was little more than a few cottages around St Andrews church until the nineteenth century, there was no need for any lighthouse or guide for this part of the channel. When one wife lit a candle and placed it in the window to aid her husband at sea, it so pleased other fishermen that they paid her a small sum to keep it burning every night for the entire local fleet. When her husband died, the local clergy paid her the sum of five pounds for the rights, placing the light on the highest point, the church tower. This later moved to the Round Tower, which is still alongside the church.

Further north along the coast is the High Light, a tower behind the dunes which did not allow for the huge tides and hence a Low Light was built. Standing on nine solid oak legs, this is thought to be a unique wooden lighthouse; 99 feet in height, it has been in almost constant use since it was built in 1832.

BURRINGTON

Not seen before the twelfth century as Buringtune, here the Old English *burh tun* tells us it was 'the farmstead of the fortified place' or possibly 'the fortified farmstead'. The parish also sees the hamlet of Bourne, itself from Old English *burna* and a reference to the brook here.

BURROW BRIDGE

In 1065, this place is recorded as Aet tham Borge, literally '(place) at the hill' and derived from Old English *beorg*.

BURTLE

Records of this place name are very recent, making it difficult to see the name of the original Saxon settlement. However, by comparing it with other names in the south-west of England, it seems the suffix here is Old English *dael* used here to mean 'hollow'. The first element is probably a Saxon personal name, but without early forms, the name could be almost anything including Bryni, Beornwynn, Burgheard, Burgwine, Burgwynn Briddel, Burgwulf, Biorg, Biargar and many, many more.

The local pub was once known as the Railway; however, since this stop on the old Somerset and Dorset branch line officially closed on 7 March 1966, the name has hardly been applicable. Thus, in 1980, the pub was renamed the Tom Mogg, yet it still kept its link to the railway. Tom was a regular at the pub, a man who worked as a signalman at nearby Edington junction. The sign depicts this popular figure in his uniform and ringing a large brass bell.

BUTCOMBE

With records of Budancumb around 1000 and Budicome in Domesday, this is thought to represent a Saxon personal name and the Old English *cumb*. Together they tell us this was the '(place in) the valley of a man called Buda'.

BUTLEIGH

Old English *leah* follows a Saxon personal name in 'the woodland clearing of a man called Budeca'. This place has records dating back to 725 as Budecaleh and as Boduchelei in Domesday.

Chapter 3

Cadbury–Cutcombe

CADBURY (NORTH AND SOUTH)

Listed as Cadanbyrig around 1000 and as Cadeberie in 1086, this name is derived from 'the stronghold of a man called Cada'. Here, the additions of North and South are self-explanatory and required for two places less than a mile apart.

Sutton Montis is a local name in this parish, the 'southern *tun* or farmstead' which was held by Drogo for the Count of Mortain at the time of the Domesday survey.

With the hill fort of Cadbury Castle having a long association with King Arthur, it was almost inevitable that the local pub would be called the Camelot.

CALE (RIVER)

Found as both Cawel and Wincawel in 956, these tenth-century records probably refer to different arms of the Cale. The difference is from a word related to Welsh *gwyn* meaning 'white' and thus the more turbulent of the two. While the origin of the river name is uncertain, it could possibly be related to *calu* and speak of it being the '(stream) of the hill'.

CAMEL (QUEEN AND WEST)

From a Celtic river name *canto* meaning 'border or region' and *mel* or 'bare hill', this name is found as Canmael in 995 and Camelle in 1086. The additions here refer to possession by Queen Eleanor in the thirteenth century, the other a clear geographical reference.

At Queen Camel, the locals enjoy a glass at the Mildmay Arms. In 1558, this manor was granted to Sir Walter Mildmay, whose descendants retained that position until 1929. The family resided at Hazelgrove House, a seventeenth-century home largely rebuilt by Carew Mildmay around 1730.

CAMELEY

Domesday records this place as Camelei, when it was a possession of Geoffrey de Mowbray and boasted a mill and a flock of 150 sheep. This name refers to itself as 'the *leah* or woodland clearing on the Cam Brook', a river name meaning 'crooked'.

CAMERTON

Domesday records this place as Camelertone, while the earlier record of Camelartone dates from 954. Here is 'the *tun* or farmstead on the Cam Brook', a Celtic river name which was earlier recorded as Cameler and probably derived from *camm*, 'crooked'.

CANNINGTON

Records of this name start in 880 as Cantuctun and as Cantoctona in 1086. This place features a corrupted form of the local range of hills and speaks of 'the farmstead of or by the Quantock Hills': a Celtic hill names and Old English *tun*.

The delightfully welcoming name of the Friendly Spirit Inn is matched by the appearance of this charming village pub. The other local advertises its wares, displaying an image of the brewer's tool on the sign of the Malt Shovel Inn.

CANON PYON

Records of Pionie in 1086 and as Pyone canonicorum in 1221 show the basic name here is derived from Old English *pie eg* and describes 'the island or dry ground in a marsh infested by gnats or similar insects'. The addition shows this was a possession by the canons of Hereford and distinguishes it from Kings Pyon nearby.

CARHAMPTON

Here is a Saxon place name from *carrum-tun* and speaking of 'the farmstead of the place by the rocks'. Listings of this name include Carrum in the ninth century and Carentone in Domesday.

The sign outside the Butchers Arms reminds us that innkeepers of yesteryear often performed two functions, most often that of the local butcher.

CARLINGCOTT

A name found in Domesday as Credelincote comes from a Saxon personal name with Old English *ing-cot* and telling of this as 'the cottages associated with a man called Cridela'.

CARY FITZPAINE

One of two places (see below) named from the River Cary, an ancient Celtic river name and probably even older, which has defied all attempts to define it. Listed as simply Cari in 1086, this addition comes from the Fitz Payn family, who were certainly here by the thirteenth century.

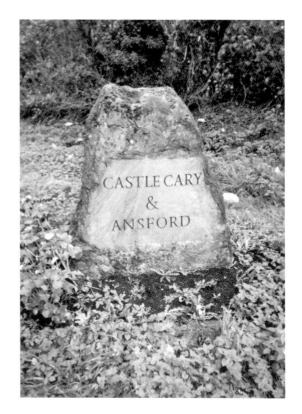

Right: Castle Cary's attractive village sign

Below: Waggon and Horses, Castle Cary

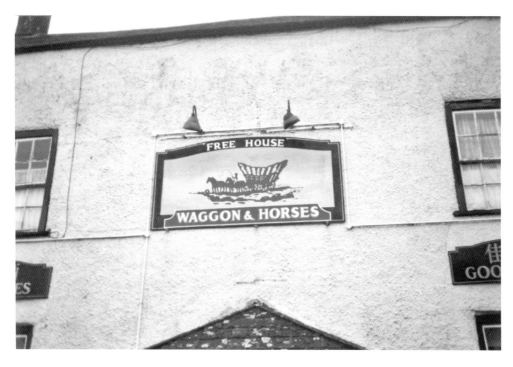

CASTLE CARY

The name is first seen as Castelkary in 1327, where the Celtic or pre-Celtic name of the River Cary is joined by Middle English *castel* and refers to the Norman castle here.

Not only the place name has a reference to water, but so do the public houses. The Brook House Inn tells us it stands alongside a small tributary of the Cary, while the Horse Pond Inn offered a drink to both horse and rider.

CATCOTT

Listings of this name include Cadicote in 1086, a name meaning 'Cada's cottages' and where a Saxon personal name is suffixed by Old English *cot*.

The locals here were happy to show their support for the monarch when they frequented the Crown Inn.

CHAFFCOMBE

A Saxon personal name and Old English *cumb* combine to speak of 'the valley of a man called Ceaffa', the place first recorded in 1086 as Caffecome.

CHAPEL ALLERTON

A name recorded as Alwarditone in Domesday in 1086, here is a Saxon personal name and Old English *tun* describing 'Aelfweard's farmstead'. The addition is self-explanatory and is derived from Middle English *chapele*.

Locally, we find Ashton, one of the most common place names in England, which refers to 'the farmstead by the ash trees'.

CHARD

Here, the basic name is seen as Cerdren in 1065 and Cerdre in 1086. This comes from Old English *ceart aern* and describes 'the building on rough ground'. Two miles south of here is South Chard, which almost certainly is an off-shoot of this place.

Pubs here include the Cerdic, named after the local foundry. A warm invitation is offered by the name of the Happy Return and the Candlelight Inn, and also in the name of Ye Olde Poppe Inne. Although note that 'Ye' in pub names is an American idea and did not appear until the nineteenth century, so not only is 'Ye Olde' not particularly old but the Americans have mistakenly used 'Ye' as 'the' when it should correctly be 'you'! The Choughs Hotel is named after the bird, a member of the crow family which frequents the sea cliffs around the South West.

As can be seen from the image of the welcoming sign, the town boasts as being the origin of powered flight. As we all learned at school, the first flight was by the Wright Brothers, Orville and Wilbur, near Dayton, Ohio, in 1903. However, there have been

Right: Welcome sign to Chard, styled 'the birthplace of powered flight'

Below: Great Western Road, Chard

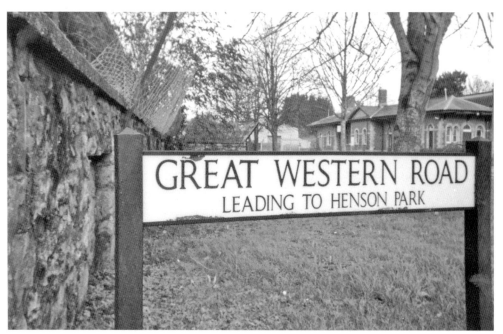

numerous claims since that this was not the first flight, mainly centring on the design of the aircraft stating that this was not the normal fixed-wing aircraft design used by virtually every aircraft since. However, in the nineteenth century, two men in Chard were producing bobbins and carriages for the lace industry, John Stringfellow and William Samuel Henson, who together had plans to launch the Aerial Transit Company with the Aerial Steam Carriage carrying ten to twelve people on flights of one thousand miles to exotic locations, with publicity citing such places as Egypt and China.

Their original machines paved the way for a 20-foot scale model craft which was tested and, after an initial failure, flew in a disused lace factory in Chard for thirty feet off a guide wire. In order to carry anyone, the machines needed to be scaled up. Here problems ensued, for this was in the days before the internal combustion engine and steam engines were much heavier and larger and constant failures broke their spirit and the partnership ended.

That this was the first powered flight is undoubted; there were witnesses to the event and it was widely reported at the time. The work of Stringfellow was acknowledged by the Wright brothers over fifty years later. Yet this first powered flight has failed to be recognised because it was indoors and, more importantly, there was nobody on board. Whether the lack of a person on board negates the claims of a first powered flight is unlikely to be resolved; however, the two men are at least honoured by the names of Stringfellow Crescent and Henson Park in Chard.

CHARLCOMBE

Recorded as Cerlecume in 1086, this place name is from Old English *ceorl cumb* and describes 'the valley of the freemen or peasants'.

The local hamlet of Woolley is found as Wilege, Willega, Willege and Wolleye between the eleventh and fourteenth centuries, a name which is derived from 'the wood where wolves are seen'.

CHARLINCH

Domesday records this name as Cerdeslinc, a personal name followed by Old English *hlinc* and telling of 'the ridge of a man called Ceolred'.

CHARLTON ADAM

One of the most common place names in England, indeed there are five in Somerset alone, Charlton comes from Old English *ceorl-tun* and speaks of 'the famstead of the freemen or peasants'. This place is listed as Cerletune in 1086 and as Cherlton Adam in the thirteenth century; the latter shows this was a possession of the fitz Adam family in the thirteenth century.

CHARLTON HORETHORNE

Listed as Ceorlatun in 950, this is another 'farmstead of the freemen or peasants'. Here, the addition is the name of the Hundred of Horethorne, former administrative region from Saxon times and referring to 'the grey thorn bush' from Old English *har-thyne*.

CHARLTON MACKERELL

With a distinctive addition from the Makerel family, this 'farmstead of the freemen or peasants' is recorded as Cerletune in 1086 and Cherletun Makerel in 1243. There is also the hamlet of West Charlton, from the same Old English *ceorl tun* with a self-explanatory addition.

CHARLTON MUSGROVE

Coming from Old English *ceorl tun* and listed as Cerletone in 1086 and Cherlton Mucegros in 1225, this 'farmstead of the freemen or peasants' was the manorial possession of the Mucegros family from the thirteenth century.

The minor names of Holbrook describes the 'brook in a hollow', Southmarsh is self-explanatory, and Shalford 'the ford across the shallow stream'. Here the local pub is the Smithy Inn, clearly occupying the same position as the old metalworker.

CHARTERHOUSE

The earliest surviving record of this name is from 1243 as Chartruse, showing it to be an unusual name in coming from Old French *chartrouse* and meaning 'the house of the Carthusian monks'.

CHEDDAR

Anyone hearing this name today has one first thought, of cheese. However the famous cheese takes its name from the place, and the place takes its name from the gorge, quite literally for this features the Old English *ceodor* meaning 'ravine'. The place is recorded as Ceodre in 880 and as Cedre in 1086.

The pubs here include the Gardeners Arms, which most likely began life as referring to a former or alternative trade of an early innkeeper.

CHEDDON FITZPAINE

Here is a name recorded as Succedene in 1086 and as Chedene in 1182. Here Old English *denu* or 'valley' follows Celtic *ced*, 'wood', and is joined by a word indicating this was a manorial holding of the Fitzpaine family, here in the thirteenth century.

CHEDZOY

One of Somerset's most interesting place names, for the form is most unusual. However, the origins are quite oridinary, from a Saxon personal name and Old English *eg* this is 'Cedd's dry ground in marsh'. The place is first listed as Chedesie in 729.

CHELVEY

Found as Claviche in 1086, this name comes from Old English *cealf-wic* and refers to this place being 'the farm where calves are reared'.

CHELWOOD

As seen in the record of Celeworde in 1086, this suffix here is not Old English *wudu* but *worth*. Preceded by a Saxon personal name, this place is 'Ceola's enclosure'.

CHERITON (NORTH AND SOUTH)

Two places listed separately as Ciretona and Cherintone in Domesday, however, they are both within a mile of a stretch of the modern A357 and must have a common origin. From Old English *cirice-tun*, these names speak of 'the farmstead with a church', while the additions are self-explanatory.

CHESTERBLADE

An unusual place name, seen in 1065 as Cesterbled and derived from two Old English elements. The first is *ceaster*, a very common element and describing 'the Roman stronghold or station'. However, this precedes a word which, while well known, is not seen in place names. The term *blaed* does indeed mean 'blade' and can only refer to a natural edge in the landscape. This theory is difficult to see today, as centuries of human influence have erased any recognisable trace of this feature.

CHEW (RIVER)

A river name which has proven a difficult name for toponymists to define. Doubtless this is a British or Celtic name, however, there is little evidence in the surviving written languages of Welsh, Cornish and Breton to assist in the search. One solitary clue may be found in the occasional record of *afon cyw*, a Welsh term and quite literally the 'chicken river'. No river today is known as such; indeed, the term should not be taken to mean poultry but used in a more general way to describe the young of any animal. If this is the case then it would be seen as a reference to the fish which return to the freshwater streams from the sea, such as salmon or, more likely here, elvers, which arrived in the spring from the Sargasso Sea.

CHEW MAGNA

This and the following name are derived from the River Chew, a Celtic or pre-Celtic river name discussed under its own entry. This place is seen as Ciw in 1065 and Chiwe in 1086 and the modern addition comes from Latin *magna* meaning 'great' and required to distinguish it from the following place.

CHEW STOKE

Two elements which have proven hard to understand, but for very different reasons. As noted in the previous name, this is named from the River Chew, a name of Celtic origin (or earlier) and which has never been understood. The addition is from Old English *stoc* and is the most common place name in the land, indeed the single early record of note comes from Domesday and is given as simply Stoches, meaning the distinctive addition here is not this element but that of the river name.

Old English *stoc* was once defined as 'special place'; however, this was often interpreted as some mystical or religious location, when all it really signified was something special to the original settlement. This could have been a religious feature, however, it is much more often simply a place where a specific crop was grown, or a particular craft was practiced. We shall never know why this place was special and, in order to prevent over-imaginative explanations for this place name, is today more often defined as 'outlying settlement'. Here this seems to fit the etymology perfectly, for it is clearly an off-shoot from Chew Magna.

CHEWTON MENDIP

A third name which comes from that of the River Chew, this time suffixed by the Old English *tun* and thus 'the farmstead on the River Chew'. Here a second suffix has appeared, a reference to the Mendips nearby. This name is recorded as Ciwtun in 880, Ciwetune in 1086 and Cheuton by Menedep in 1313.

Here we find a region known as Bathway, derived from its location near 'the way or road to Bath'. The local pub is the Waldegrave Arms, named after the family who lived at the large Gothic mansion house by 1791.

CHILCOMPTON

Found in Domesday as Comtuna and as Childecumpton in 1227, this comes from Old English *cild cumb tun* and describes 'the freemen of the village farmstead'.

Here we find the Redan Inn, a name which is associated with the Crimean War and refers to the kind of military trench which was developed at the siege of Sebastopol.

CHILLINGTON

The imporatance of finding as many early forms as possible is highlighted by this name, for while there are clear similarities between this and the previous name, a record of 1261 as Cheleton shows this is a modern coincidence. Here a Saxon personal name and Old English *tun* describe this as 'Ceola's farmstead'.

CHILHORNE DOMER

Found in Domesday as Cilterne and as Chilterne Dunmere in 1280, this is similar to the previous two names but features a third different origin for the first element. The first element is thought to represent a word which is based on Celtic or pre-Celtic *celte* or *cilte* and referring to a 'hill slope'. The addition is not seen until the thirteenth century when the Dummere family arrived to run the manor.

CHILTON CANTELO

A name found as Childeton in 1201 and as Chiltone Cauntilo in 1361, this name comes from Old English *cilde tun*, a common combination, meaning 'the farmstead of the young noblemen'. The addition here is manorial, a reference to the Cantelu family who were here by 1221.

The hamlet of Ashington is here too, recorded as Essentone in 1086 and Estinton in 1186, this name is derived from the Old English for 'the farmstead in the east'.

CHILTON TRINITY

Another Chilton, another Old English *cilde tun*, and another 'farmstead of the young noblemen'. Here the addition is from the dedication of the church of Holy Trinity.

CHILTON POLDEN

Found as Ceptone in 1086 and Chauton in 1303, this name has been influenced by the other Chiltons of Somerset and elsewhere in England, but has a quite different etymology. This name comes from Old English *cealc tun* and tells us it was 'the farmstead on the land of chalk or limestone'. The addition, a comparatively recent development, is a reference to the nearby Polden Hills.

Records of the Polden Hills survive from 725 as Poeldune, featuring the Old English suffix *dun* and describing it as 'the hill known as Bouelt'. This earlier name is not recorded, but comes from a Celtic term meaning 'the cow pastures'.

CHINNOCK (EAST, MIDDLE AND WEST)

Three places separated by no more than two short miles and doubtless having a single common ancestry. While the additions are clear and self-explanatory, the basic name is rather corrupted and is not certain. Recorded as Cinnuc in 950 and Cinlioch in 1086, this name is possibly from Old English *cinu* and 'the deep valley', however, it could represent an earlier hill name of Celtic origins and is thus unknown.

At East Chinnock, the pub is the Portman Arms, named after the family who held this manor from 1539.

CHIPSTABLE

Recorded as Cipestaple in 1086 and as Chippestapel in 1251, a name which comes from a Saxon personal name and Old English *stapol* and refers to 'Cippa's marker post'.

Locally we find Raddington, a name recorded as Radingtone in 891 and as Radingetune in Domesday. This would be a Saxon personal name (probably a nickname) with Old English *ing tun* and referring to 'the farmstead associated with a man called Raed'.

CHISELBOROUGH

A name recorded as Ceoselbergon in Domesday, a name from Old English *cisel beorg* and referring to 'the gravel mound or hill'.

The annual Chiselborough Fair was held on the region around the street which is now known as Fair Place.

CHRISTON

Despite how it appears in the modern form, this has no connections with Christianity, at least from the etymological perspective. Found in 1197 as Crucheston, a combination of Celtic *crig* and Old English *tun* gives this as 'the farmstead by a hill'.

CHURCHILL

The earliest surviving record comes from 1201 as Cherchille and, as with other places of this name elsewhere, has no connection with a church. Here Celtic *crug*, meaning 'hill', was taken to be the name of the hill by the Saxons, who added their own *hyll* to this and produced a name meaning 'hill hill'.

One public house here is the Stag & Hounds, undoubtedly a hunting reference, the second is the Nelsons Arms, named after the man named as England's greatest hero and who has more pubs named after him than any other individual.

CHURCHSTANTON

Domesday records this name as simply Stantone, which is Old English *stan tun* and describes 'the farmstead on stony ground'. Later this place is found as Ceristone in the thirteenth century which, unlike the previous name, does show a connection to the church and is derived from Old English *cirice*.

Burnworthy is a local name derived from *burna worthig* and meaning 'the enclosure by the stream'.

CLAPTON

A name not seen before 1243 and then exactly as the modern form may seem to lack sufficient different examples to help define the name. However, this is a common enough name and is always from Old English *cloppa tun*, describing 'the farmstead of or near the hills'.

The local pub is the Crown, a simple visual sign which conveys a message of loyalty to both king and country and explains why it is one of the three most common names in the land.

CLAPTON IN GORDANO

Recorded as Clotune in 1086, as Clopton in 1225 and as Clopton Gordeyne in 1270, this is another *cloppa-tun* or 'the farmstead of the hills'. The addition, to distinguish this place from the above, is an old district name and comes from Old English *gor denu* and is 'the muddy valley'.

CLATWORTHY

Found in Domesday as Clateurde and as Clatewurthy in 1243, there can by no doubt this is Old English *clate worth*, meaning 'the enclosure where burdock grows'. The tap root was used as a root vegetable, the immature flower stalks were cooked much the same as the related artichoke; it is one part of the popular soft drink dandelion and burdock; the seeds are used in Chinese medicine, while the root oils were used to treat hair loss, dandruff and scalp problems. In more recent times, Swiss George de Mestral was walking his dog and was intrigued by the burdock seeds which caught in the coat of his pet. On arriving home, he examined the seed cases under the microscope and noted how the hooks and loops enabled the seed to hitch a ride on passing animals and thus distribute seeds across a wide area. A system which nature had developed through evolution was the inspiration for Velcro, which the doctor soon patented.

CLAVERHAM

A name derived from Old English *claefre ing* and recorded as Claveham in Domesday, this tells us it was 'the homestead where clover grows'. Seen only as a pleasant splash of

colour in the wild and an unwanted weed in lawns and flowerbeds, to the Saxons it was quite different. Clover was a valuable food item, high in protein; they make a nutritious juice when boiled and the dried flowerheads and seedpods were ground up to improve greatly the quality of flour.

CLAVERTON

Although it does not seem it from the modern form, the records of Clatfordtun around 1000 and Claftertone in Domesday show this is of similar origins to Clatworthy above. Here is Old English *clate ford tun* which describes the 'farmstead by the ford where burdock grows'.

CLEEVE

From Old English *clif* and listed in 1243 as Clive, this is the '(place at) the cliff or bank'.

CLEVEDON

The similarity between this and the previous name is obvious. Recorded as Clivedon in 1086, this name comes from Old English *clif dun* and describes 'the hill of or by the cliffs'.

The Crab Apple public house is situated among a small orchard of apple trees. The Little Harp Inn suggests a link to Ireland and, more importantly, is an easily recognised image even in silhouette.

CLEWER

While the previous two entires show a distinct similarity, this also has the same Old English element while the pronunciation tends to mask this. Here Old English *clif ware* tells us it was 'the dwellers on the river bank'. The place is recorded as Cliveware in 1086.

CLOSWORTH

A name recorded in the eleventh century as Clovewrde, Clovesuurda, and Clouesword, all of which point to Old English *clof worth* and a meaning of 'the enclosure at the crevice'.

Pendomer is a local name, which is derived from British or Celtic *penn* or 'hill' and the family name of Domer, who are recorded several times around here. Also found here is Sutton Bingham, another 'southern *tun* or farmstead' here held by John de Bingham at some time shortly after the Conquest.

Clutton's Millennium Marker Stone

CLUTTON

A name recorded as Cluttone in 851 and as Clutone in 1086, this comes from Old English *clud tun* and describes 'the farmstead at the rocky hill'.

COKER (EAST, NORTH AND WEST)

Listed as Cocre in Domesday, this name refers to a Celtic river name here which itself describes it as 'crooked, writhing'. The three places are all within an area of a mile and thus require the obvious additions.

The local pub at East Coker is the Helyar Arms, a reminder of the powerful family who owned lands here for many generations. A reminder of their heyday exists to the south of the village: a tree planted on their estate is a narrow-leaved elm which has escaped the ravages of Dutch elm disease. Planted by the Helyars, they would be proud to learn this tree has been adjudged the finest free-standing example of this variety in Europe.

COLE

A name found in several places in England and with almost as many different origins. It is thought to refer to a Celtic river name but, as there are no records of such, it is difficult to interpret this name. The place name itself is not recorded prior to 1212, when it is seen as Colna.

COLEFORD

A name which can readily be seen as having similarities with the previous name, however, the origins here are known and are quite different. This place is recorded as Culeford in 1234, and comes from Old English *col ford* or 'the ford across which charcoal is carried'. Defining this name tells us more than just a description of the place, for if it was known for a place where charcoal was carried through, we can also infer from this that the charcoal was produced on the opposite side of the river from the settlement. This gives us an image of the charcoal burner in the foreground tending his smouldering mound of earth and cut wood, with the cart or pack animals laden with charcoal crossing the river to reach the settlement in the distance on the other side. Defining a place name can offer more than meets the eye.

The local here is the Eagle, a popular pub name since at least the fifteenth century with many possible origins. The very mention of this magnificent bird of prey conveys an image of strength and splendour, hence it being used as a symbol in a vast array of coats of arms while also representing three of the most powerful nations on the planet, USA, Russia and Germany. In churches it represents St John the Evangelist, which is why it decorates many a lectern; for the Romans it adorned their military insignia; and when man first travelled to the Moon, the craft touched down on the Sea of Tranquility with the words 'The Eagle has landed'. However, it seems likely that the bird has been chosen as, once again, simply an instantly recognisable image.

COMBE FLOREY

From Old English *cumb*, this is a common place name and particularly in the South West of England. Here this is 'the valley' and has the addition from it being the manor held by the de Flury family, here from the twelfth century. The name is recorded as Cumba in the twelfth century and as Cumbeflori in 1291. There is also an Eastcombe here too, 'the eastern place in the valley'.

COMBE HAY

Another example of the common Old English element *cumb* and recorded as Come in 1086 and Cumbehawya in 1249. Here 'the valley' was held by the de Haweie family in the thirteenth century.

COMBE ST NICHOLAS

A name seen in Domesday as simply Cumbe, which takes its addition from the dedication of the priory at Exeter, and is the '(place in) the valley with a church dedicated to St Nicholas'.

The pub here is the Green Dragon Inn, nothing to do with St George but a heraldic symbol pointing to the earls of Pembroke, a title which has become extinct and been recreated several times since the reign of King Stephen.

COMBWICH

With records of Comich, Commiz and Cumwiz in the eleventh and twelfth centuries, this is seen as Old English *cumb wic* and describes 'the specialised farm in a valley'; most often this referred to a dairy farm.

COMEYTROWE

A twentieth-century development to ease the growing housing problem in Taunton. However, the place name had existed for centuries; from *cumb atte treow*, this describes 'the valley at the tree(s)'.

COMPTON BISHOP

Records of this name include Cumbtune in 1067 and Compton Escopi in 1332. Here Old English *cumb tun* refers to 'the farmstead in the valley', a common name and requiring the addition to distinguish this from others. Here that addition is from its early possession by the Bishop of Wells.

To the east is the hamlet of Cross, two of the roads which unite here are known as Old Coach Road which, while self-explanatory, also shows this has long been a major crossroads and helps to define this name. Here is the hamlet of Rackley, which was once a trading port on the River Axe with its own wharf where cloth and corn were shipped out as far as Portugal and iron and salt were brought in, although today the course of the river has been diverted. This is the origin of this name, the *atter Axe leah* or 'at the River Axe woodland clearing'.

COMPTON DANDO

Listed as Contone in 1086 and Cumton Daunon in 1256, here is the common 'the farmstead in or of the valley', here with the addition of the Dauno family (possibly de Auno),who were lords of this manor in the twelfth century.

COMPTON DUNDON

This 'farmstead in the valley' takes its second distinguishing element from the nearby village of Dundon, itself another reference to the valley and discussed under its own entry.

The local pub here is the Castlebrook Inn, the brook refers to the source of fresh water which any settlement needs and the castle is the Iron Age hill fort excavated in 1916.

COMPTON MARTIN

Another 'farmstead in the valley', this place is recorded as Comtone in 1086 and Cumpton Martin in 1228 and takes the name of Martin de Tours, whose son held this manor in the early twelfth century and clearly named it in honour of his father.

COMPTON PAUNCEFOOT

As if to show how common a place name this is, here is the fourth example of 'the farmstead in a valley'. The similarity does not end there, for this also includes another name relating to a manorial family name, here the Pauncefote family from the thirteenth century.

CONGRESBURY

Early records of this place include Cungresbyri in the ninth century and Cungresberie in 1086; here is 'the fortified place associated with Saint Congar'. This is a Celtic personal name and is suffixed by the Old English *burh*.

One local here is the Plough, a pub name common since the sixteenth century and clearly an invitation to those living in a rural community.

CORFE

A name found in 1243 as Corf, this clearly comes from Old English *coft* and describes this as '(the place) at the cutting or pass'.

The local here is the White Hart, which remains a popular pub name having started out as a heraldic image representing Richard II's reign in the late fourteenth century.

CORSTON

With records of Corsantune in 941 and Corstune in 1086, this is 'the *tun* or farmstead on the River Corse'. Here is an old Celtic river name from *mors* and meaning 'marsh'.

CORTON DENHAM

A name found in 1086 as Corfetone and referring to this as 'the farmstead at the pass', it is derived from Old English *corf tun*. Here the manorial addition comes from it being the possession of the de Dinan family, who were here in the early thirteenth century.

COSSINGTON

The earliest surviving record of this name is as Cosingtone in 729 and later as Cosintone in 1086. Here the Saxon personal name is followed by Old English *ing tun*, telling us it was 'the farmstead associated with a man called Cosa or Cossa'.

Any confusion as to the origins of the name of the Red Tile Inn is cleared up as soon as one sees the building, for the whitewashed walls of the building accentuate the very red tile roof.

COTHELSTONE

This name has changed little since it was first seen as Cothelestone in 1327. Here the name of the Saxon individual is followed by Old English *tun*, telling us it was 'Cuthwulf's farmstead'.

COXLEY

Found as Cokesleg in 1207, this name is derived from Old English *coc leah* and means 'the woodland clearing of the cook'. Domesday records that this place was held by a woman in 1086, an unremarkable fact but one which ties this to the place name, for we are also aware that the woman was married to a member of the royal household, where he was a cook.

The local here is the Pound Inn, which would have taken the name already on the map before it was built here. As a nation of crofters and farmers, it was inevitable that animals would stray, thus the community employed a man to round up the strays, only to release them back to their owner on payment of a fine. This produced revenue to pay his wage and prevented livestock wandering wherever they wished. The place where they were held was called the pound, although more often the pinfold, and the man who controlled such the pinner, which is the origin of the surname.

CRANMORE (EAST & WEST)

A name recorded as Cranemere in the tenth century and as Crenemelle in Domesday, this name comes from Old English *cran mere* and refers to 'the pool frequented by cranes or heron'. The additions are self-explanatory and necessary, for these places will have had a common origin and are less than a mile apart.

The local name of Dean, from Old English *denu* meaning 'valley', is still seen in the form of Dean Farmhouse which dates from at least the seventeenth century.

CREECH ST MICHAEL

Derived from Celtic *crug* and recorded in Domesday as Crice, this name speaks of being the '(place at) the mound or hill'. The addition is, along with so many in the South West, a reference to the dedication of the church.

Locally we find the name of Adsborough which, lacking many early records, is difficult to define with any certainty but is likely to be something akin to 'Aeddi's or Eadda's outlying settlement'.

CREWKERNE

The earliest surviving record of this name is from the ninth century as Crucern, while Domesday shows this as Cruche. This name is of Celtic origins and speaks of it as 'the building of or at the hill'. Here this is Celtic *crug ern* or possibly the suffix is Old English and thus *crug earn*, yet the meaning is the same.

Pubs here include the Old Stage Coach Inn, clearly a stop on the cross-country coaching routes of yesteryear. The name of the Antelope Inn is heraldic, however, the image was adopted by so many families, it is difficult to know whether this refers to the Duke of Gloucester, Duke of Bedford, Henry IV, Henry V, or Henry VI.

Surely one of the most endearing pub name etymologies in the county, if not in the country, is found at the Muddled Man. The present building dates back to the middle of the seventeenth century when it was a weaver's cottage; it was not for another 150 years that it first became licensed premises, for the sale of beer and cider only. At the time, it was not the only pub in the parish, the Half Moon was further along the road and hence it was 'the newer inn'.

In the 1960s, the Half Moon closed and it was around this time the local council wielded their pedantic pen and decided all pubs which did not offer accommodation could not call themselves inns. Hence a change of name was required for, unlike other inn names, the name could not simply drop this element: this would then have simply been the 'New'. Looking to a local point to point racehorse, which ran the West Chinnock to Chisleburgh steeplechase course, the pub was renamed after the horse and became the Salamander and stayed as such until the 1970s when a new landlord was unhappy with the name.

Trying to think up a new name for anything is never as easy as it sounds and pubs are harder than most. To add to the landlord's woes, his wife had been admitted to hospital and he was left to look after the home, the pub, his young family and, worst of all, the accounts. In the days before home computing, the company books were just that, books in which credits and debits were entered by hand. In public houses, this function was inevitably the task taken on by the landlady, so when the poor man arrived at the hospital with all the paperwork one evening and managed to drop the lot in a heap on the floor, his wife exclaimed how he was such a 'muddled man'. A passing nurse, who had come to know them, remarked on how well suited this would be as a pub name for it also aptly described most men when they were just a little the worse for the drink.

The brewery agreed to the name change and the present sign is the result of a competition held to redesign the sign, which had become tatty. Open to children, it depicts the name perfectly well.

The aptly-named Windwhistle Inn on top of the hill at Cricket St Thomas

CRICKET ST THOMAS

Recorded as Cruche in Domesday and as Cruk Thomas in 1291, this name comes from the same element as the previous name. Here Celtic *crug* combines with Old French *ette* to describe 'the little mound or hill', or perhaps 'the little place at the mound or hill'. The addition is another place to show the dedication of its church.

Certainly the hill which gives Crewkerne its name will make it open to the wind. However, the name of the Windwhistle public house is a little overstated and a nightmare for those designing the sign!

CROSCOMBE

Found in 705 as Correges cumb and in Domesday as Coriscoma, this name comes from Old English *corf weg cumb* and is 'the valley of the road to or of the pass'.

One landlord wanted to ensure nobody forgot his beloved pet, so he named his pub after his Bull Terrier.

Signpost at Croscombe

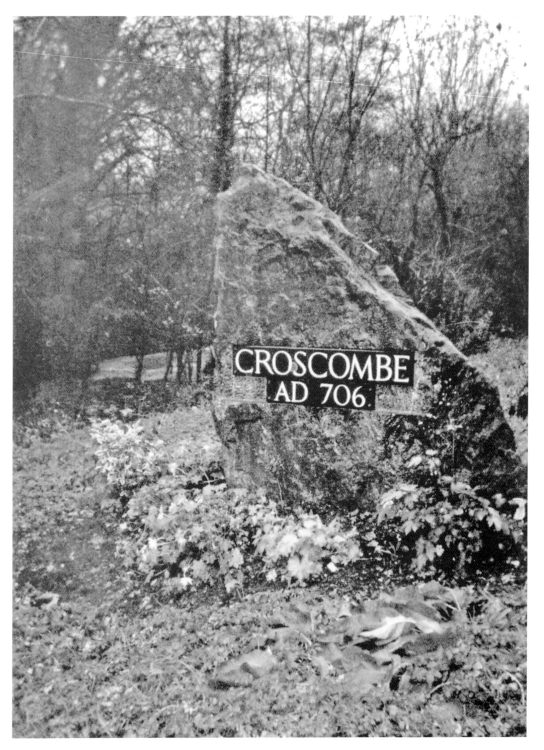

Croscombe, founded in AD706, or that is the earliest record of the place

The George Inn, Croscombe

CROWCOMBE

From Old English *crawe cumb*, this is 'the valley frequented by crows' and is seen as Crawancumb in the tenth century and as Crawecumbe in 1086. The hamlet of Crowcombe Heathfield means eactly what it says, 'the open land on the heath belonging to Crowcombe'.

Flaxpool tells us this was where the fibrous parts of the flax were separated by immersion in the pool in a process known as retting. The hamlet of Halsway is first seen in 1080 as Healswege, which refers to its position between two hills and describes 'the pass road'. Lawford is a hamlet with a name derived from the Old English 'Lealla's ford'.

The village pub commemorates the family who served their country in several prominent positions over the centuries, including Lord Lieutenant of Cornwall, and who well merit the name of the Carew Arms.

CUCKLINGTON

Here is a place name featuring a Saxon personal name and Old English *ing tun*. Listed as Cocintone in 1086 and Cukelingeton in 1212, this is 'the farmstead associated with a man called Cucol or Cucola'.

CUDWORTH

Listed in Domesday as Cudeworde in 1086, this points to 'Cuda's enclosure' and with a Saxon personal name followed by Old English *worth*.

CURLAND

In 1252, this name is found as Curiland, a name which points to the origin of 'Curry's cultivated land' and where the personal name is followed by the Old English *land*.

CURRY (RIVER)

Whilst this name has never been defined with any certainty, the most likely origin is a Celtic or British *crwy*, which suggests this was 'a boundary stream'. Very few rivers and streams do not serve as a natural boundary for at least some part of their course.

CURRY (MALLET, RIVEL AND NORTH)

No more than three miles separate any of these places and each is probably historically linked to the other in some way. From the etymological viewpoint, the connection is a Celtic river name, the Curi, which is discussed under its own entry. The additions come from the location of one, being to the north, and to the manorial holdings of the remaining two, being the possession of the Malet and Revel families from the twelfth century. These places are recorded as Curig in the ninth century, Curi and Nortcuri in 1086, Curi Malet and Curry Revel in 1225.

Here is Burton Pynsent, a reminder of the estate owned by Sir William Pynsent until his death in 1756 when he left it to William Pitt (the Elder) in recognition of his political career. The basic name is a common one, derived from *burh tun* and describing the 'fortification of or by a farmstead'.

At North Curry the local is the Bird in Hand, a popular name since the seventeenth century and based on the adage 'A bird in the hand is worth two in the bush'.

CUTCOMBE

Found as Codecoma in 1084 and Cudecumba in 1178, this is derived from 'Cuda's valley'.

Dinder–Durston

DINDER

Found in 1174 as Dinre, this is something of a rarity in England, a place name derived
from the ancient Celtic or British language spoken in these islands prior to the arrival
of the Romans some 2000 years ago. This tongue is normally only found in the names
of topographical features such as hills and rivers. There was no written form, however,
we know the language by association with related languages which do have written
forms and indeed are still spoken, such as Welsh, Gaelic, Cornish and Breton. Here the
elements *din-brez* combine to describe 'the hill with a fort'.

DINNINGTON

Recorded in Domesday as Dinnitone, this name comes from a Saxon personal name and
Old English *ing tun*, giving 'the farmstead associated with a man called Dynne'.

DITCHEAT

An Old English name featuring the elements *dic geat* and speaking of 'the entrance or
gap in the dyke or earthwork'. Records of this name survive from 842 and 1086.

DONYATT

With records of Duuegete in the eighth century and Doniet in Domesday, this name
features a combination of a Saxon personal name and the Old English *geat*. Often given
as being a 'gate or gap', the term *geat* is probably better defined as 'route, way', for the
others suggest the entranceway when the real meaning is that which leads to (or from)
the place – as is the case here with 'Dunna's geat'.

DOULTING

Listed as Dulting in 725 and Doltin in 1086, this name was taken from the river on
which it stands, that is, the earlier name of the River Sheppey. However, there is no
written record of this and the meaning is unknown.

The swollen River Axe at Dinder

The minor place name of Boddon is understood, derived from a Saxon personal name and Old English *dun* and referring to 'Boda's hill'. Prestleigh is derived from Old English *preost leah* and tells of 'the woodland clearing of the priests'. Two pubs here have contrasting names: the Waggon & Horses refers to the legitimate method of transporting goods before railways and canals, while the Poachers Pocket comes from a little used term today, describing large pockets found in a coat and which were deemed to have been copied from the huge pockets used to hide game which had been acquired illegally.

DOWLISH WAKE

Found as Duuelis in 1086 and Duueliz Wak in 1243, this name comes from the Celtic or British river name and refers to 'the dark stream'. The addition is a manorial one and a reference to the Wake family, who were here by the twelfth century.

DOWNHEAD

Records of Duneafd and Dunehefde, in 851 and 1086 respectively, show this name to be from Old English *dun heafod* and to be speaking of the '(place at) the end of the down'.

The local name of Tadhill lacks many early examples but is probably derived from 'Tata's hill'.

DRAYCOTT

A common place name, from Old English *draeg cot*, the name literally speaks of 'drag cottages' and is understood to mean 'the building where sledges are kept'. The term *draeg* is often seen when near a river; it refers to where cargo (or even the boats themselves) were dragged across a created slipway alongside the river in order to avoid a barrier, such as a minor waterfall or large rocks in the bed of the river. Here the sledges were likely stored in order to provide a method of transportation on a regular basis.

The local here tells its own story, featuring a GWR pannier tank engine hauling a truck of overly large strawberries. This is a reminder that, before Lord Beeching got his hands on the Cheddar Valley line, fruit vans were a common sight along here. The pub was named the Strawberry Special to mark this line, which closed in 1968.

DRAYTON

As with the previous name, this features the Old English element *draeg*, here suffixed by *tun* and describing 'the portage at the farmstead'. A portage is, as described above, where the goods were dragged alongside the river to avoid a natural obstruction in the river. The name is recorded in the modern form as early as 1243.

DULVERTON

Found in Domesday as Dolvertune, this name features three Old English elements, *diegel ford tun*, and tells us this was 'the farmstead of or near the hidden ford'. The ford would not have been hidden deliberately and thus was probably overgrown.

Locally we find the name of the hamlet of Battleton. There is no record of any major battle here and, if it mirrors similar minor names elsewhere, would refer to 'the disputed farmstead or *tun*'. Pubs here include the Rock House Inn, named from the rocky outcrop here, and the George Inn which was used to refer to any of the three Hanoverian kings who collectively reigned from 1714 to 1801.

DUNBALL

A name which has few records and none are sufficiently early enough to assist with a definition. However the name most likely comes from Old English *dun halh* and 'the nook of land on or by a hill or slope'.

DUNDON

From Old English *dun denu* and listed as Dondeme in 1086 and Dunden in 1236, this is the '(place at) the valley by the hill'.

DUNDRY

Found as Dundreg in 1065, this name is probably from the Old English *dun draeg* and, as with Draycott and Drayton above, is where 'loads are dragged on the hill slope'. Alternatively, the second element may be the earlier Celtic name of the place and, with the term *din*, refers to 'the fort named Draeg'.

The hamlet of Maiden Head speaks of 'the headland of the maidens': somewhere associated with womenfolk.

DUNKERTON

A name listed as Duncretone in 1086 and as the modern form as early as 1225. This comes from a British word related to Welsh *din* 'hill fort' and Cornish *dun* 'rock', which should probably be understood as 'the *tun* or farmstead associated with the hill'.

DUNSTER

Domesday's record of Torre features the Old English element *torr*, but not the personal name featured in the later record of Dunestore in 1138. This place has a name meaning 'Dunn's craggy hill'.

Aside from the castle, Dunster's most famous sight is the yarn market. Built around 1590 by George Luttrell, it enabled traders and their wares to shelter from the weather. The Luttrell family were living at Dunster Castle, also giving their name to the local pub, the Luttrell Arms.

DURLEIGH

Recorded as Derlege in Domesday, this is the Old English *deor leah* or 'the woodland clearing frequented by deer'.

DURSTON

Another Domesday record here, in Derstona, which points to the Old English *tun* following a Saxon personal name and therefore 'Deor's farmstead'. This is probably a nickname, for not only is it used to mean 'deer' but is also seen as referring to 'animals' in general.

Chapter 5

East Lambrook–Exton

EAST LAMBROOK

Found as Landbroc in 1065, this name comes from Old English *land broc*, a name referring to the 'cultivated land by a brook'. The addition is to distinguish this from other Lambrooks nearby.

EASTON IN GORDANO

One of the most common place names of the English counties and very often requiring a second element to distinguish it from others. Here the name comes from Old English *east tun*, referring to 'the eastern farmstead', and recorded as Estone in Domesday. Later the name is found as Eston in Gordon in 1293, which adds an old district name from Old English *gor denu* and refers to 'the muddy valley'.

EAST PENNARD

A name recorded as Pengerd in 681, a Celtic name from either *penn garth* and 'the hill of the ridge' or *penn ardd*, 'the high hill'.

Here we find Huxham Green, a Saxon name describing 'Hoc's homestead' with 'Green' a comparatively modern addition. While there are few records of the name of Parbrook, it seems likely this is from *per broc* and describes 'the brook where pear trees grow'. Stone is a common name, simply from *stan* or 'the stony place'. The local here is the Travellers Rest, an invitation to passers-by to drop in for refreshment.

EDINGTON

The only record of this name is in Domesday as Eduuintone. This is a Saxon personal name and Old English *tun* and describes this as 'the farmstead of a man called Eadwine or a woman called Eadwynn'.

ELWORTHY

The sole surviving early record of this place comes from Domesday as Elwrde. Here the Saxon personal name combines with Old English *worth* to tell us of 'Ella's enclosure'.

The hamlet of Willett is also a river name discussed under its own entry.

EMBOROUGH

A place name found in Domesday as Amelberge and as Emeneberge in 1200, this name comes from the Old English *emn beorg* and tells us of the 'flat-topped mound or hill'.

ENGLISHCOMBE

A record of Ingeliscum in Domesday unites a Saxon personal name and an Old English *cumb* to give an origin of 'Ingel or Ingweald's valley'.

ENMORE

This place name is recorded as Animere in Domesday and is an Old English name from *ened mere* and telling us it was '(the place at) the duck pool'. The hamlet of Bare Ash is an example of how a prominent or unusual tree can be a signpost visible from a distance; here it is quite likely that the ash tree was deliberately stripped of at least some of its branches in order to point travellers in the right direction.

The locals drink at the Tynte Arms, named for Colonel Tynte, who bought it for his old sergeant-major, Edward Calland, who in turn changed the name of the place.

EVERCREECH

With records of Evorcric in 1065 and Evrecriz in 1086, this features a Celtic element, *crug* meaning 'hill', while the first element is thought to be either Old English *eofor* 'wild boar' or a Celtic reference to a 'yew tree'.

Stoney Stratton is found as Strettun in 1065 and as Stratton in 1262. This is a common name, referring to 'the farmstead of or by the Roman road' and here with the addition telling us it was 'stony ground' around here.

The Bell Inn shows the long relationship between the village pub and the church, while the Shapway Inn takes the name of that settlement to the north-east.

EXE (RIVER)

A Celtic river name which tells us this describes simply 'the waters', as with most Celtic or British names, it is quite simple in its meaning. The name is recorded as early as AD

Road sign at Priestleigh, near Evercreech

150 by the Greek Ptolemy as *Iska* and is also found as Andlang Eaxan in 937; the root is related to Welsh *usk*.

EXEBRIDGE

The earliest surviving record of this name is Exebrigge in 1255, a Celtic river name (see above) with Old English *brycg*, which can still be seen as 'bridge'.

EXFORD

As with the previous name, this is 'the ford over the River Exe', the river name is discussed above. Early listings of this name include Aisseford in 1086 and Exeford in 1243.

Lyncombe is a hamlet which most likely takes its name from Old English *hlynn cumb* and describes 'the torrent in a valley'

EXTON

This Somerset place name is another with Old English *tun* following the Celtic river name Exe (see above) and is simply 'the farmstead on the River Exe'. The only early form of note is as the modern form in 1216.

The name of Bridgetown is a modern form of Old English *brycg tun* and describes 'the farmstead by the bridge'.

Failand–Fulford

FAILAND

A name which comes from Old English *falle land* and tells us it was 'the cultivated land which falls away'. There is also a Lower Failand and the local pub takes the name as the Failand Arms.

FARLEIGH HUNGERFORD

As with the subsequent two entries, the first element here is Old English *fearn*, here suffixed by leah and telling us of 'the woodland clearing where ferns are growing'. This name is recorded as Fearnleagh in 987, Ferlege in 1086, and Farlegh Hungerford in 1404; the addition is from the Hungerford family, here by the fourteenth century. They have also given their name to the local pub, the Hungerford Arms.

FARMBOROUGH

Listed as Fearnberngas in 901 and Ferenberge in 1086, this place name is derived from Old English *fearn beorg* and describes the 'hills or mounds overgrown with ferns'.

FARRINGTON GURNEY

The only early record of this name is in Domesday as Ferentone. This is similar to the previous entry in being from Old English *fearn tun* or 'the farmstead where fearns grow', although this is not to suggest that this was a crop. The addition, of comparatively recent beginnings, refers to the de Gurnay family, who were here by the thirteenth century.

FAULKLAND

The sole surviving early record of this place comes from 1243 as Fouklande, which can still be seen as being literally 'the folk land'. This tells us this was the land held owing to folk right, or long-standing law, and coming from Old English *folc land*.

FIDDINGTON

A place name found in Domesday as Fitintone, which comes from a Saxon personal name and Old English *ing tun* and tells us of 'the farmstead associated with a man called Fita'.

FITZHEAD

A name which is recorded as Fifhida in 1065, a name which was changed almost beyond recognition over the next thousand years. However, this eleventh-century name is easily seen as coming from Old English *fif hid* or 'the place of five hides' – a hide is a region of land which averages around 30 acres, but can vary widely, as it refers to productivity rather than area.

FIVEHEAD

This place name is identical in origin with the previous name, although it is much easier to see this as 'the place of five hides'. It is recorded as Fifhide in Domesday.

FLAX BOURTON

A place name which features the common *burh tun* or 'the farmstead with or by a fortification'. Invariably, these names also have a second distinguishing element, here a reminder this was where flax was grown.

The local pub, formerly called the Jubilee Inn, has been renamed as the welcoming Dew Drop Inn.

FRESHFORD

With records surviving from around 1000 as Ferscesford, here is a name from Old English *fersc ford* and describing 'the ford over the freshwater stream'. The pub tells its own location in the name of the Inn at Freshford.

On the outskirts of the village, and officially in the parish of Hinton Charterhouse, is a site associated with the Carthusian Priory. This has given a site to The Friary and Friary Wood.

FROME

Named from the River Frome, which is Celtic and refers to this being 'fair, fine, brisk'. The earliest surviving record of the place name shows exactly how to pronounce it, for in the eighth century this is Froom.

Street names around the town show various aspects of the history of the place, remembering people, places and events. Residents who gave their name include the

Naish family, who gave their name to Naish's Street. Selwood Close remembers John Selwood, who worked this land around the eighteenth century. Nail Street may seem to be a trade name, and originally it will have been, however, it came here through a surname, itself from the trade name and an ancestor of William Nayle, who rented property here in 1735. Friggle Street is a very old name, probably much older than its earliest known record from 1231. This name refers to a metalled or perhaps paved track to help prevent excess wear, something which we would normally attribute to the Romans but which was probably named by the Saxons.

Trooper Street took its name from the Trooper Inn, not the reverse. Bell Lane marks the site of a foundry set up by Warminster bell founder Lewis Cockey. The Mint is a street name which speaks for itself, although this was not a mint for coins but medals or trade tokens, such were only good between selected tradesmen and removed the problem of counterfeiting and would prove worthless to a thief. However, the best of them all is Limerick lane, named for the number of Irish refugees who were commonly found around the county around 1690. These were Protestants, fleeing Catholic-dominated Ireland which supported the recently dethroned James II against William and Mary who were now on the throne of England, making Somerset a very desirable place to be.

Pub names here include the Vine, a pub which indeed does have grapevines growing over one wall of the pub and an ideal, if seasonal, advertisement. The Blue Boar Inn is an old pub name, heraldic in origin and traceable back to the Earl of Oxford. The Lamb & Fountain features the emblem of the Plumbers' Company and a reminder of the Lamb Brewery, who were founded in Frome. The stoneworkers were granted a coat of arms in 1473; this is displayed on the sign outside the Masons Arms.

FULFORD

Found in 1327 as Fuleforde, this is a name from Old English *ful ford* and describes the 'foul or dirty ford'.

Chapter 7

Galhampton–Greinton

GALHAMPTON

The earliest surviving record comes from 1199 as Galmeton. This comes from Old English *gafol mann tun* and describes 'the farmstead of the peasants paying rent.

GLASTONBURY

A name found in 751 as Glastingburi and in 1086 as Glaesngeberia. Here are three elements, the first seems to be a Celtic place name of Glaston, with Old English *inga burh* and describing 'the stronghold of the people of Glaston'.

It is thought that the Celtic name of this place comes from a term meaning 'the place of the woad'. Woad is the plant also known as glastum, *Isatis tinctoria*, and even the Asp of Jerusalem. Many will know it only as the blue dye used to colour the skin of the Picts, itself derived from the Latin meaning 'painted ones'. The plant is not native to Britain but to the steppe and desert regions of the Caucasus, Central Asia, Eastern Siberia and Western Asia. Although it was eventually cultivated in this country, it formed a staple of the trade routes from the east until the sixteenth century, as it was the only blue dye available for cloth and even, in later times, paint. In recent times, it is being studied closely, as scientists feel it may prove useful in the battle against cancer.

Locally is the minor name of Beckery, sometimes given as Beckery Island. In 971, this name is found as Bekeria que parva Ybernia dicitur, and in 1227 as Beckerie. The basic name is from Old Irish *bec Eriu*, meaning 'little Ireland', a name found several times when referring to offshore islands around the Emerald Isle. This can only have been brought here by Irish monks.

Pubs here include the Mitre Inn, the hat worn by bishops and showing an association with the church. The town has long been associated with the legendary king of England and it was inevitable that one pub would be called the King Arthur. The Rose & Portcullis unites two easily recognised symbols. The flower represents the Tudors and the distinctive design of the sliding gate, which was found on the reverse of the old pre-decimal threepenny bit, represents security and strength.

One of the most heart-warming stories of any pub in the land comes from Glastonbury. During the war, servicemen and locals alike would while away their free hours at the Lamb Hotel. Years later, the son of a former owner returned to find the place in a most dilapidated condition. He and his wife enquired and, almost before they had drawn breath, had bought the place. The new landlord began extensive renovation, rebuilding a wall, replastering and buying new furniture before they could even open the doors for

business. Then he turned his attention to the upstairs, new plumbing, more plastering, and decorating, all the while never once mentioning the name of the place. Eventually, the place was restored to a standard which pleased the landlord who, standing back to admire the finished pub, exclaimed, 'Who would have thought it?' – from that day on the pub has been known as the Who'd A Thought It.

GOATHURST

Found in Domesday as Gahers and in 1292 as Gothurste, here is a name coming from Old English *gat hyrst* and referring to the 'wooded hill where goats are kept'.

GODNEY

An unusual name coming from a Saxon personal name with Old English *eg* and speaking of the 'dry ground in wetland of a man called Goda'. The place is recorded as Godeneia in the tenth century and is an excellent pointer to Somerset's long history: it was first settled in Mesolithic or Middle Stone Age times, anywhere between seven and twelve thousand years ago, depending upon the region. This would have been a region of Somerset reached by something akin to the Sweet Track, a wooden trackway named after Ray Sweet who discovered it in 1970. Dendrochronology, or tree-ring dating, puts the timbers of this track as being built in 3807 or 3806 BC, making this wooden road across marshland one of the oldest known roads in the world and certainly the oldest datable route.

More recent archaeology has found a second path, known as the Post Track, running alongside it and claimed to be some 30 years older. Possibly an early example of a road-widening scheme.

GREAT ELM

Here is a name referring to the '(place at) the elm trees', with the addition referring to this being the larger place named after elms and not the trees themselves. Domesday records this as Telma in 1086, with the addition of the 'T' all that remains of the Old English *aet* meaning 'at'.

Locally we find the name of Hapsford, derived from a Saxon personal name and telling of 'Haep's ford'.

GREINTON

Domesday records this place as Graintone in 1086, a name from a Saxon personal name and Old English *tun* and speaking of this as 'the farmstead of a man called Graega'.

Chapter 8

Hallatrow–Hutton

HALLATROW

The earliest surviving record comes from Domesday as Helgetrev in 1086. This comes from Old English *halig treow* and describes the '(place by) the holy tree'.

HALSE

A name found exactly as the modern form in 1086, with the Domesday record showing this to be from Old English *hals* and describing the '(place at) the neck of land'.

HAMBRIDGE

The modern name suggests a bridge, however, historically this was a 'ridge'. This feature is identical to the reference of the second element *hamm*, an Old English term referring to 'hemmed-in land'. A look at the map will show Hambridge lies between two rivers which converge just north of here. Thus this 'ridge of hemmed in land' describes the location quite well. The hamlet of Westport describes itself as 'the place to the west of here'.

The local pub here is the Lamb & Lion, a name which replaced the earlier New Inn. It was named by the local vicar whose sermon remarked that his flock would enter the pub as meekly as lambs and emerge roaring like lions. He offered to repaint the sign to define the name and it still hangs here today.

HAMDON HILL

A name which comes from Old English *hamm dun* and refers to 'the hill of the hemmed-in places'.

HARDINGTON

This place name comes from a Saxon personal name and Old English *ing tun*, which show this to be 'the farmstead associated with a man called Hearda'. The place is listed in Domesday as Hardintone.

HARDINGTON MANDEVILLE

As with the previous name, this is listed as Hardintone in Domesday and describes this as 'the farmstead associated with a man called Hearda'. The addition, to distinguish it from the above, refers to this manor being a possession of the de Manderville family from the twelfth century, this family also giving their name to the local pub, the Mandeville Arms.

HARPTREE (EAST AND WEST)

Two places separated by around two miles, hence the addition for clarification, although the names would be more accurate descriptions as North and South. Undoubtedly, there was one original place, it recorded as Harpetreu in Domesday and referring to 'the tree by the highway or main road'. This certainly comes from Old English *here paeth treow*, and probably refers to West Harptree.

HASELBURY PLUCKNETT

Listed in Domesday as Halberge, this name comes from Old English *haesel bearu* and describing 'the hazel wood grove'. The addition refers to this manor being held by the de Plugenet family and, although the record is not seen until 1431 as Haselbare Ploukenet, this family were certainly here by the thirteenth century.

HATCH BEAUCHAMP

A common element in place names, this basic name comes from Old English *haecc*, referring to either 'a hatch gate', that is, one leading to a forest or 'a floodgate' used to control the flow of a stream for irrigation purposes or to power a mill. Here the manor was held by the Beauchamp family from the thirteenth century, the name being found as Hache in 1086 and as Hache Beauchampe in 1243. The local pub is simply named the Hatch Inn.

HAWKRIDGE

Listed in 1194 as Hauekerega, this is derived from Old English *hafoc hrycg* and describes the '(place at) the ridge frequented by hawks'.

HEATHFIELD

A fairly common place name and, as with all such names, one which has a simple meaning. Found in Domesday as Hafella and in a document of 1159 as Hathfield, this is from Old English *haeth feld* and describes the 'open land of or by the heath'.

HEMINGTON

Listed in Domesday as Hammingtona, this place name features a Saxon personal name and Old English *ing tun*, which tells us this was 'the farmstead associated with a man called Hemma or Hemmi'.

The local name of Foxcote would hardly seem to be 'the cottage of the foxes', so either the *cot* here is used in place of a 'foxes' earth' or the first element is a personal name, likely a nickname.

HENLEY

A name found across England, usually with a second defining element. This place name is found in 973 as Henleighe, which comes from Old English *heah leah* and means this was 'the high or chief woodland clearing'.

HENSTRIDGE

Recorded as Hengsterig in 956 and as Hengesterich in 1086, this name is of Old English origin from *hengest hrycg* describing 'the ridge of land where stallions are kept'. However, this may also be a personal name and give 'Hengest's ridge of land'.

The local pub here is the Virginia Ash, not a tree but a story which unfolds on the sign. Here we see Sir Walter Raleigh, the man who sailed the Atlantic and landed at what is now known as Virginia, famously bringing back the potato and tobacco, hence the ash. Behind the famous explorer stands a man with a bucket of water, suggesting that maybe he was unsure if Raleigh was actually on fire.

HENTON

Two possible meanings for the place listed in 1065 as Hentun. This may either be from Old English *heah tun*, 'the high or chief farmstead', or *henn tun* and 'the farmstead where hens are kept'.

HEWISH (EAST AND WEST)

Three places all separated by less than a mile, with records of Hiwis in 1198 and Hywys in 1327. This name comes from Old English *hwisc* and tells us this was 'the measure of land which would support a family'.

HIGHBRIDGE

Listed in 1324 exactly as it is today, this name comes from Old English *heah brycg* and refers to this as 'the high (most important) bridge'.

The local pubs here include the Coopers Arms, a reminder that, before the days of metal kegs, the cooper, or maker of barrels and casks, was a vital link in the chain to bring drink to the public. The Bason Bridge Inn was named after the bridge which was rebuilt when the Glastonbury Canal came through here. Another bridge gave its name to the Bristol Bridge, this time a much bigger and certainly higher construction, the Clifton Suspension Bridge. Linking Bristol with North Somerset, it has a total length of 1,352 feet, is 31 feet wide, and carries traffic 702 feet above the River Avon. Opened in 1864, it still continues to carry 4 million vehicles every year.

HIGH HAM

Found in 973 as Hamme and in 1086 as Hame, this name comes from Old English *hamm* and refers to this being 'the hemmed-in land'. Here the addition of 'high' refers to its status and not the elevation above sea level.

HIGH LITTLETON

With the addition to distinguish this place from Littleton and of obvious origins, the basic name is recorded as Liteltone in 1086 and as Heghelitleton in 1324. Here is the 'higher little farmstead'.

The hamlet of Amesbury is found as Ambresbyrig in 880, a name meaning 'Ambr's fortified place'.

HILLFARANCE

An unusual name due to a very odd evolution. In 1086, this name appears as Hilla, quite clearly from Old English *hyll* and the '(place at) the hill'. In 1253, this name is seen as Hull Ferun, the addition coming from it being held by the Furon family, however, to find the manorial element not only having become a part of the main name but also to have changed so appreciably is very unusual indeed.

HINTON BLEWETT

The basic name here comes from Old English *heah tun* or 'the high or chief farmstead', and is listed as Hantone in Domesday. By 1246, the listing shows this place had become known as Hentun Bluet and refers to this place being held by the Bluet family by that time.

HINTON CHARTERHOUSE

Recorded as Hantone in Domesday and as Henton Charterus in 1273, here is a name which speaks of 'the high or chief farmstead' being held by the Carthusian monks, the priory being founded here in the thirteenth century.

The local is the Stag Inn, the easily recognised image of the male roe deer in its prime and a symbol of the hunt.

HINTON ST GEORGE

A third 'high or chief farmstead', and one recorded as Hantone in Domesday. This name appears as Hentun Sancti Georgii in 1246, here the Latin version of St George and showing the dedication of the church.

HOLCOMBE

The earliest surviving record of this place name comes from 1243 as Holecumbe, easily seen as coming from Old English *hol cumb* and 'the place in the deep or hollow valley'.

HOLFORD

Domesday lists this place name as Holeforde, which comes from Old English *hol ford* and tells us this was 'the ford in a hollow'. From this we can deduce this was probably a ford which had been in use for some considerable time, for the term is applied to a 'hollow' which is not natural but worn by the repreated and long-term passage of traffic.

Holford's Plough Inn features an instantly recognisable symbol and one which fits perfectly in the rural location.

HOLTON

A common place name and always from Old English *healh tun* or 'the farmstead at the nook of land'. The place is recorded as Healhtun around AD 1000.

HORNBLOTTON GREEN

A most unusual name indeed, which comes from Old English *horn blawere tun* and describes 'the farmstead of the hornblowers or trumpeters'. Recorded in 851 as Hornblawertone and in 1086 as Horblawetone, the addition of 'Green' is a modern one.

HORRINGTON (EAST, WEST AND SOUTH)

Three places less than a mile apart sharing a single common origin in 'the hill of the people living at the horn-shaped region of land'. Recorded as Hornningdun in 1065, this name comes from Old English *horna inga dun*.

HORSINGTON

Domesday records the name as Horstenetone in 1086, a name which comes from Old English *hors thegn tun* and describes this as 'the farmstead of the horsekeepers or grooms'.

HORTON

This place appears exactly as its modern form since 1242; this comes from Old English *horh tun* or 'the farmstead on muddy land'.

HUISH CHAMPFLOWER

A place name which features an alternative spelling of Old English *hiwisc*, also seen as Hewish (see above). Recorded as Hiwis in 1086 and as Hywys Champflur in 1274, this name refers to 'a measure of land which would support a family' and one which was the domain of the Champflur family, here by the thirteenth century.

HUISH EPSICOPI

Found as Hiwissh in 973, here is 'the measure of land enough to support a family' has an addition referring to its possession by the Bishop of Wells.

HUNSTRETE

A name which is thought to describes 'the road to or of the hundred', from Old English *hund strete*.

HUNTSPILL

Recorded as Honspil in 1086, here is a name derived from a Saxon personal name and Old English *pyll* referring to 'the tidal creek of a man called Hun'. Two settlements East Huntspill and West Huntspill are located either side of the M5, itself the best-known reference to the name in the form of the Huntspill river marked by a sign on that motorway. At West Huntspill, the Crossways Inn shows that, even before the motorway, this was a meeting place for the local network of tracks and paths. The Royal Artillery Arms shows the regimental badge; this company claims to be the oldest and most senior regiment of the British Army.

East Huntspill has an area simply known as Cote, from Old English *cot*, telling us this was where there were 'cottages', while the name of Alstone, recorded as Aelfsigestun in 969, is a name from 'Aelfsige's *tun* or farmstead'.

HUNTWORTH

From a name meaning 'the enclosure of the huntsman' and Old English *hunta worth*, this name is recorded as Hunteworde in Domesday. Alternatively, this first element may represent the Saxon personal name Hunta.

Here the local pub is the Boat & Anchor, a name which refers to its location on the River Parrett.

HUTTON

Listed in 1086 as Hotune, this name comes from Old English *hoh tun* and refers to 'the farmstead on a hill-spur of land'.

The local here is the Old Inn, a name which should correctly be seen as the 'older' inn and one which has outlived the competition.

Chapter 9

Ilchester–Isle Brewers

ILCHESTER

Listed in Domesday as Givelcestre, this name reflects three phases in the history of the county: Celtic, Roman and Saxon cultures. This name refers to 'the Roman stronghold on the River Gifl', where the river name being followed by Old English *ceaster*. This Celtic river name, describing 'the forked river', is an early name for the River Yeo.

The local is the Bull Inn, often depicted as the animal but most often referring to the papacy, for the seal on the official documents of the Pope is referred to as a Papal bull.

Minor names here include that of Sock Dennis (which is also occasionally known as Stock-Dennis). Recorded as both Soca and Soche in Domesday, the addition is not seen until 1257 as Sok Deneys. This basic name comes from Old English *soc* literally meaning 'sucking' and referring to the way the land soaked up the water as in a quagmire or marsh. At the time of Domesday, this place was held by Robert Fitzivo, by 1236 the lord of the manor was given as Johannes Dacus, this surname being a Latinised version of the Old French *deneis* and meaning 'Danish'.

ILFORD

A small village recorded as Ileford in 1260 and telling us of 'the ford across the River Isle', a name discussed under its own entry.

ILMINSTER

Records of this name include Illemynister in 955 and Ileminstre in 1086, the name referring to 'the large church on the River Isle'. This is a Celtic river name, discussed under its own entry, followed by the Old English *mynster*.

Local pubs include the Dolphin, linked to the sea through heraldic imagery, the Crown Inn, a clear show of support for the monarchy, and the New Inn, a name pointing to a more recently founded drinking establishment.

Within the parish is the hamlet of Peasmarsh, a name describing 'the marshland where peas are grown'.

The road of Riec-Sur-Belon Way is named after the town in Bretagne, France, which was twinned with Ilminster.

Above: This road in Ilminster takes the name of its twin town in France

Left: Attractive welcome to Ilminster

ILTON

Another settlement on the River Isle, which is discussed below. Listed in 1086 as Atiltone and in 1243 as Ilton, the Old English *tun* is the suffix here and describes 'the farmstead on the River Isle'.

ISLE, RIVER

Records of this name include Yle in 693 and as Ile in 1280, a Celtic or British river name which is of uncertain origin, for the Celtic tongue can only be seen through comparisons with other related languages such as Welsh, Breton and Cornish. Furthermore, these ancient languages can also be seen as being related to others derived from the ancient languages of the Indo-European group, such as Greek, Latin, Gaelic and Sanskrit.

It is thought this name could be related to the Scottish River Ilidh, earlier the Ila Ptol and related to the Greek root *pi* or *pino* 'to drink' or perhaps Norw ila 'a spring'. Whatever the real origin here, we can be sure it would be as simplistic as to describe running water.

ISLE ABBOTTS

Recorded as Ile Abbatis in 1291, this name refers to 'the settlement on the River Isle belonging to Muchelney Abbey'.

ISLE BREWERS

Found in 1275 as Ile Brywer, this name tells us it was 'the settlement on the River Isle held by the Briwer family'.

The hamlet of North Bradon would seem to be from *brad dun* or 'the broad hill'; however, this does not appear to fit with the topography. Thus the second element is probably *tun* meaning 'farmstead', while the addition is to distinguish it from the parishes of South Bradon and Goose Bradon.

Chapter 10

Kelston–Knowle St Giles

KELSTON

Recorded as Calveston in 1178, this name features the common Old English suffix *tun* with an uncertain first element. However, it has been suggested this could be a Saxon personal name, thus giving 'Cealf's farmstead'.

KENN

A place name which comes from the name of the streams on which the place stands. Recorded in Domesday as Chent, neither place name or river name have ever been understood.

The pub here is the Drum & Monkey, a name which remembers the travellers who moved from town to town entertaining the locals with a monkey who would perform a routine of tricks on a drum.

KEINTON MANDEVILLE

Domesday lists this place as Chintune, a name which comes from Old English *cyne tun* or 'the king's manor'. Later, in 1280, the name is found as Kyngton Maundevill and is a reference to the Maundevill family who were lords of this manor from the thirteenth century.

Here the Lakeview Quarry specialises in stone for paving and walling, hence the name of the Quarry Inn.

KEWSTOKE

Domesday records this name as Chiwestoch in 1086, where the name of the Celtic St Kew precedes Old English *stoc* or 'secondary settlement'. This man was said to be a monk, one who lived in a cell on top of Worle Hill (also referred to a Monk's Hill) reached by a long flight of steps leading up the ravine here. There is evidence of an Iron Age settlement here, although the name suggests these steps were set much later and are known as either Monk's Steps or more often St Kew's Steps.

KEYNSHAM

Listings of this name include Caegineshamme around 1000 and Cainesham in 1086; here is a Saxon personal name, with Old English *hamm* and referring to 'the land in a river bend of a man called Caegin'.

KILMERSDON

Records of this name are seen as Kunemersdon in 951 and Chenemeresdone in 1086, where a Saxon personal name precedes Old English *dun* and speaks of 'the hill of a man called Cynemaer'.

KILTON

A place name referring to this as 'the farmstead of or by the club-shaped hill' and derived from Old English *cylfe tun*. Listings of this name include Cylfantin in 880 and Chilvetune in 1086.

KILVE

Similar to the previous name, this comes from Old English *cylfe* and describes 'the club-shaped hill' and is seen as Clive in Domesday and as Kylve in 1243.

KINGSBURY EPISCOPI

Documented as Cyncgesbyrig in 1065 and as Chingesberie in 1086, this name comes from Old English *cyning burh*, literally 'the king's manor'; however, the Latin addition of *episcopi* also shows it was also held by the Bishop of Bath.

William Wyndham was lord of this manor in the latter half of the nineteenth century, hence the name of the local pub, the Wyndham Arms.

Hamlets here include East Lambrook and West Lambrook, names recorded as Landbroc in 1065, Lambrok in 1201, Lanbroc in 1227, and Estlambrok in 1268. The additions are clear, while the basic name is from Old English *land broc* and is 'the brook by cultivated land', understood to refer to a boundary stream.

KINGSDON

Listed as Kingesdon in 1194, this comes from Old English *cyning dun* and refers to 'the king's hill'.

KINGS PYON

Here the addition distinguishes it from nearby Canon Pyon, showing possession by the Crown. The basic name is derived from Old English *pie eg* or 'the island or dry ground in marsh infested by gnats or similar insects'. The place is recorded as Pionie in 1086 and as Kings Pyon as early as 1285.

KINGSTON SEYMOUR

As with the following name, this comes from 'the king's manor'; here the place is found as Chingestone in Domesday. The addition is a reference to the family who held this manor, ultimately from the town of St Maur in Normandy, from where they took their name.

KINGSTON ST MARY

From Old English *cyning tun* or 'the king's manor', this is a common name and hence the addition, here the dedication of the church.

KINGSTONE

Listed as Chingestana in 1086, this name comes from Old English *cyning stan* and describes 'the king's boundary stone'.

This parish had previously been known as Allowenshay, recorded as such from about 1280. This name is seen as Aylwynesheye in 1315 and is derived from 'Aethelwine's enclosure'.

KINGWESTON

This is found as Chinwardestune in Domesday, a name which tells us this was originally 'Cyneheard's *tun* or farmstead'.

KNOWLE ST GILES

A name found in 1189 as Knolle and in 1285 as Cnolle, this name is derived from Old Enlish *cnoll* meaning 'hillock' and with the addition of the dedication of the local church for such a common name.

Locally we find Cricket Malherbie, found as Cruchet in Domesday, Cruket in 1201, and Cryket Malherbe in 1320. Here Celtic *crug* combines with Old French *ette*, describing 'the little hill'. In 1228, this was held by Robert Malherbe, hence the addition.

Lamyatt–Lyng

LAMYATT

Here is a name documented as Lambageate in the late tenth century and as Lamieta in Domesday, a place name which comes from Old English *lamb geat* and describes 'the gate for gap for lambs'.

LANGFORD BUDVILLE

Found as Langeford in 1212 and as Langeford Budevill in 1305, this Old English *lang ford* or 'the long ford' was held by the de Buddevill family from at least the thirteenth century.

LANGPORT

From Old English *lang port*, this place name refers to it being 'the long market place', easily seen as the stalls lining both sides of a street rather than in the town square as was usually the case. The earliest surviving record of this name is as Longport in 930.

The pub known as the Halfway House is situated to the east of the village, midway between here and Somerton. The Old Custom House formerly accommodated those who worked as Customs officers and has recently been restored to its former glory with money from the church.

LANGRIDGE

Domesday lists this place as Lancheris in 1086, while by 1225 the name is found as Langerig. Clearly this is from Old English *lang hrycg* and describes the '(place at) the long ridge'.

LATTIFORD

Found in 1086 as Lodereforda, Domesday's record shows this to be Old English *loddere ford*, which describes 'the ford frequented by beggars'.

Clearly in order for the name to stick, the appearance of these beggars must have been expected, which raises the question as to what was attracting them to this place.

St Peter's Church, Langford Budville

Crossing points on rivers, bridges and more often fords were rarely natural and were not common. A ford would not often occur naturally, and even when it did, the constant passage of livestock would soon erode the riverbed and quickly make it useless. Thus fords were maintained and repaired; use of the crossing point would require payment of a toll in order to pay for the upkeep of the ford itself. This is not to suggest the beggars were charging a toll and maintaining the ford. On the contrary, it is probably the place where they congregated knowing the place was unmanned and knowing they would encounter travellers and thus possibly obtain handouts.

LAVERTON

A name found in a number of places in England. This version is seen in Domesday as Lavretone, from Old English *lawerce tun* and referring to 'the farmstead frequented by larks'.

LEIGH-UPON-MENDIP

Recorded as Leage around 1000, this name comes from Old English *leah* or the '(place at) the woodland clearing'. The addition, to distinguish it from Abbots Leigh, refers to the Mendip Hills, discussed under their own entry.

LILSTOCK

Found in Domesday as Lulestoch, here is a name featuring a Saxon personal name and Old English *stoc* and telling of 'the outlying place of a man called Lylla'.

LIMINGTON

In Domesday, this name appears as Limingtone, with later records of Limintone in 1200, Liminton in 1235, and as Lemington in 1243. Here is 'the farmstead of the settlement on the River Lymn'. Here is a river, a tributary of the Yeo, with a British river name referring to it being 'by the elm trees'. It is related to the Old Irish *lem* and Welsh *llwyf*. The name can also be seen mirrored in the English rivers Leam and Lemon, Scotland's Leven, and in Gaulish, the rivers Lemonum and Lemannus.

LITTLETON

From Old English *lytel tun* and recorded as Liteltone in Domesday, there is little surprise to find this name tells of it being 'the little farmstead'.

LITTON

With records of Hlytton in 1060 and Littune in 1086, this comes from Old English *hlid tun* and describes 'the farmstead at or by a slope'.

LOCKING

The earliest surviving record comes from 1212 as Lockin. This is either derived from a Saxon personal name and Old English *ing* and thus 'the place associated with a man called Locc', or perhaps Old English *locing*, 'the place of the fold or enclosure'.

The Coach House Inn shows it was one of the many stops on the old coaching routes of England.

LONG ASHTON

This Old English place name is derived from Old English *lang aesc tun* and meaning 'the long farmstead where the ash trees grow'. The name is recorded as Estune in 1086 and Longe Asshton in 1467.

LONG LOAD

Not recorded before 1285 as La Lade, this name comes from Old English *lad* and means 'the watercourse, the drainage channel'. The additional Long is a corruption of the early French La.

LONG SUTTON

Found as Sudton in 878, as Sutune in 1086, and as Langesutton in 1312, the basic name is a common one and is derived from Old English *suth tun* or 'the southern farmstead'. The addition here, expected for such a common place name, is Old English *lang* or 'long' and refers to the way the place is stretched out along the road.

LOPEN

Found in the pages of Domesday as Lopene, this name comes from the Celtic *penn* meaning 'hill' or the Old English *penn*, 'enclosure or fold'. Such diverse definitions are unusual, yet without other early forms for comparison and with the first element completely obscure, these are the only elements which are understood.

LOVINGTON

A name found in 1086 as Lovintune, this features a Saxon personal name and Old English *ing tun* and tells us it was 'the farmstead associated with a man called Lufa'.

Here we find the hamlet of Wheathill; listed as Watehelle in 1086 and as Whethull in 1331, it still recalls 'the hill where wheat grows'.

LOWER AISHOLT

Listed as Aescholt in 1086, this name comes from Old English *aesc holt* and speaks of the '(place at) the ash tree wood'.

LOWER VEXFORD

A name found in Domesday as Fescheforde, this name is derived from Old English *fersc ford* and describes 'the freshwater ford', which is neither brackish nor influenced by the tides.

LOXTON

A name which describes itself as 'the farmstead on the stream called the Lox Yeo' and which is recorded as Lochestone in Domesday. Here are three elements, Old English *ea tun* following a Celtic river name of unknown origins and meaning.

LUCCOMBE

Domesday records this name as Locumbe, which appears to point to a Saxon personal name with Old English *cumb* and describing 'the valley of a man called Lufa'.

The minor name of Horner is from *horna* or 'corner of land'. Locally we find Stoke Pero, found as Stoche in 1086 and as Stoke Pyro in 1326, and a name describing 'the outlying farmstead held by William de Pyrhou', who was here in 1243.

LULLINGTON

A name also found in Derbyshire and with the identical meaning of 'the farmstead associated with a man called Lulla', although this would not be the same person. Here the Saxon name is followed by Old English *ing tun*.

LUXBOROUGH

Found in the Domesday record as Lolochesberie in 1086, this name comes from a Saxon personal name with Old English *burh* or *beorg*, giving 'Lulluc's stronghold or hill'.

The hamlet of Kingsbridge can still be seen to take its name from 'the ridge of land in the possession of the crown', while the name of Pooltown describes 'the pool by the hill', the ending is a 'down' and never has been a 'town'.

LYDEARD (ST LAWRENCE AND BISHOP'S)

Records of the basic name date from as early as 854 as Lidegeard, while Domesday gives the name as both Lidiard and Lediart. The best understanding of this name is as *led garth*, a Celtic term describing 'the grey ridge'. The two places are around two miles apart, Lydeard St Lawrence taking the dedication of the local church, Bishop's Lydeard showing early possession by the Bishop of Wells.

Here is the minor name of Hoccombe, 'the corner of land in a valley'. The Bird in Hand is a name which reminds us of the phrase which continues '… is worth two in the bush' and suggests this was the place to be. The Blue Ball Inn is the heraldic representation of the Courtenay family, earls of Devon.

LYDFORD

A name which comes from Old English *hlyde ford* and describes 'the ford across the noisy stream'. The name is recorded as Lideford in 1086. There are three Lydords here, East and West Lydford have self-explanatory additions, while Lydford on Fosse stands on the famous Roman road which is named from the *fossa* or 'ditch' which allowed surface water to drain away.

LYMPSHAM

With the earliest surviving record coming from 1189 as Limpelesham, the record is a little late for the name to be defined with any certainty. The first element may be a Saxon personal name, which is suffixed by Old English *ham* or *hamm*, and thus 'Limpel's homestead' or 'the hemmed-in land of a man called Limpel'.

The hamlet of Wick comes from Old English *wic* or 'specialised farm', most likely a dairy farm.

LYNG

Early records of Lengen in the tenth century and Lege in Domesday show this to be from Old English *lengen* which can still be seen as literally 'length'. This is understood as 'the long place', for while most settlements were naturally as circular as the terrain would allow, others like Lyng were unnaturally long, which could be thought to represent a settlement aligned along an existing trackway. There are officially two settlements here, East Lyng and West Lyng.

Here we find the hamlet of Bankland, from Middle English *banke* and Old English *land* and describing 'the cultivated land near the bank'.

Maperton–Mudgley

MAPERTON

A name recorded as Malpertone in 1086, and as Maperton for the first time in 1219. This comes from Old English *mapuldor tun* and describes 'the farmstead near the maple trees'.

MARK

Here is a name which is first found in 1065 as Mercen. Here is a name from Old English *mearc aern* and describing 'the house or building near the boundary'. While the very mention of a boundary today suggests a political or administrative line drawn on a map, historically a boundary was a natural feature, be it a ridge of land or the merest trickle of water.

 The long relationship between the inn or tavern and the horse is shown by two pubs in Mark. The Pack Horse Inn is a reminder of the sturdy animals which were used to transport loads of corn, wool, salt, even ore over short distances. The Nags Head was originally a pointer to these small ponies being available for hire.

MARKSBURY

Records of this name include Merkesburi in 936 and Mercesberie in 1086. This is possibly a Saxon personal name with Old English *burh* and telling us of 'the stronghold of a man called Maered or Mearc'. Alternatively, the first element may be the same as seen in the name of the previous entry of Mark, thus the alternative is Old English *mearc burh*, 'the stronghold on the boundary', in which case the boundary will have been what is now known as Wansdyke.

MARSTON BIGOT

Found as Mersitone in Domesday and as Merston Bygod in 1348, this name is another *mersc tun* or 'the farmstead by the marsh', this time held by Richard le Bigod from around 1195.

MARSTON MAGNA

A name listed as Merstone in 1086 and as Great Merston in 1248, this is a common place name which comes from Old English *mersc tun* or 'the farmstead of the marshland'. The surprise here is in the way the Latin *Magna*, meaning 'great', has replaced the original English word and which can only have come through the written record as this was the only usage of Latin where place names are concerned.

The local pub is called the Marston Arms.

MARTOCK

From Old English *mere tun* or 'the farmstead by a pool', this name is recorded as Mertoch in 1086. However, there are some schools of thought which give the origins as Old English *gemaere tun* or 'the farmstead near a boundary'.

Locally we find the minor name of Hurst, from Old English *hyrst* and describing 'the wooded hill'.

There are a number of pubs known as the Baker's Arms and, before the arms were granted in the sixteenth century, which show how the landlord and the baker in a village were often the same person. The George Inn is an old name originally referring to the patron saint of England but later any of the six kings, and particularly the first four, who were known by this name.

A theme of trees is applied to the names of Ashfield Park, Elmleigh Road, Beech Road, Birch Road, and Chestnut Road.

MEARE

A name meaning the '(place at) the pool or lake', this comes from Old English *mere* and indeed is listed as Mere in Domesday.

The local Railway Inn was built when the train service arrived in the latter half of the nineteenth century.

MELLS

With the earliest records of this name as Milne in 942 and as Mulle in 1086, this is easily seen as coming from Old English *myln* and referring to 'the mills' here.

The Talbot is a fifteenth-century pub which gets its name from the breed of dog, bred by the Talbot family, which was the ancestor of the foxhound. White with black spots, its remarkable sense of smell, sturdy compact frame, and great stamina made it ideal for the hunt.

MENDIP HILLS

While the earliest record of this name is not found until 1185 as Menedepe, this name is certainly from the much earlier Celtic language. Here the basis is *monith*, a term

referring to 'the mountain, hill', which is probably followed by Old English *yppe* meaning 'upland plateau'.

MERRIOTT

Listed in Domesday as Meriet, this name comes from Old English *maere geat* and describes 'the boundary gate'.

MIDDLEZOY

Found as Sowerie in 726, as Sowi in 1086, and as Middlesowy in 1227, this name describes 'the island of the River Sow'. This is a lost Celtic (or earlier) river name with the much later addition of *middel*.

MIDFORD

The earliest surviving record is as Mitford in 1001, this comes from Old English *myth ford* and describes 'the ford at the confluence of two streams'.

MIDSOMER NORTON

Here the basic name is very common, found across England, and coming from Old English *north tun* or 'the farmstead to the north'. Additions for such a common element are to be expected, although here the name has come about by a quite unusual route. The name refers, albeit indirectly, to the dedication of the church to St John the Baptist, a saint whose feast day is Midsummer Day.

Two pubs here, the Wunderbar is the local music venue which combines the idea of a 'wonder bar' with Cole Porter's song from *Kiss Me Kate*. The second pub is the Mallards, a name which does not seem to refer to the well-known duck, nor does it commemorate the fastest steam locomotive of all time, which can only leave a family name but no record of such has been traced.

MILBORNE PORT

A name recorded as Mylenburnan in 880, as Meleburne in 1086, and as Milleburnport in 1249. Here the basic name comes from Old English *myln burna*, 'the mill stream', while the addition is also Old English from *port*, here used in its original sense of 'market town'.

Also here is Milborne Wick, another place at 'the mill stream' and here with an addition from *wic* or 'specialised farm' which probably refers to a dairy farm.

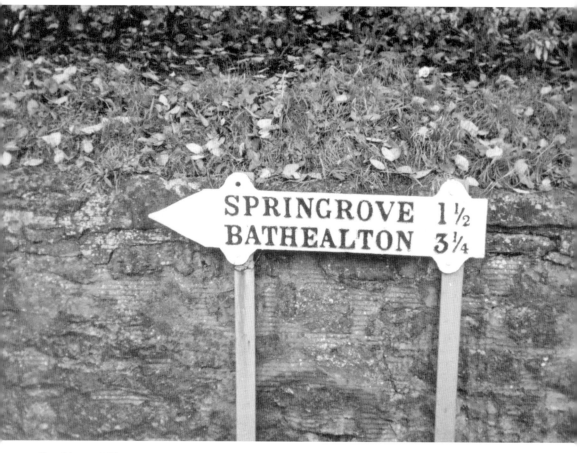

Roadsign at Milverton

MILTON CLEVEDON

A name which is derived from Old English *middel tun* and refers to 'the middle farmstead', that is, between two others. Here the addition is taken from the family of Clyvedon, lords of this manor by 1200. This name is recorded as Mideltune in 1086 and Milton Clyvedon in 1408.

MILVERTON

A name listed in the eleventh century as Milferton, this comes from Old English *myln ford* or 'the farmstead by the mill ford'.

The hamlet of Preston Bowyer takes its name from the names of two former lords of this manor; in the thirteenth century, it came under William Briwere, which has become corrupted to Bowyer, and in the first part of the eleventh century was granted by Edith of Wessex to Bishop Gisa, hence the Preston or 'priests' farmstead'.

MINEHEAD

Here is a name which combines Celtic *monith* or 'mountain' and Old English *heafod* 'projection, hill spur', and is recorded as Mynheafdon in 1046 and as Manheve in 1086. For those familiar with the area, there is an obvious location for the site of the settlement named after the hill, while the name of Minehead is synonymous with the traditional British seaside image. Indeed, in the 1880s, Summerland Street was built specifically to house Victorian holidaymakers, while today the name has changed to Summerland Road.

The Old Ship Aground public house makes use of the seaside location to refer to a sailor, not his vessel, who has retired and come ashore as an innkeeper. The Hobby Horse Inn recalls a local tradition that such were utilised to instill fear into Viking raiders. This seems to be stretching the truth a little, for these horses are those formerly ridden by children, the horse's head on one end of a pole and (for the deluxe models) a wheel on the other end. No book on English history would be complete without mentioning morris dancing, for a wickerwork (or similar) frame was worn by the dancer who then pranced around in the hope of replicating some strange equinesque gait.

The resort is the start of the South West Coastal Path, which continues for 630 miles around the coasts of Somerset, North Devon, Cornwall, South Devon, to Poole in Dorset, making it the longest continuously marked path in the land. Walking the entire length is challenging enough, there are a number of climbs to hike up, most notably the 1,043 feet Great Hangman near Combe Martin – indeed, the total uphill stretches mean ascending no less than 114,931 feet, approaching four times the height of Everest.

MISTERTON

From Old English *mynster tun*, this name tells us of 'the farmstead with a church, or one belonging to a monastery', this name is recorded as Mintreston in 1199.

The Globe is a popular pub name for it suggests the place welcomes all while also enabling sign painters to depict a simple and easily recognised image.

MONARCH'S WAY

While some would dispute if this is actually a place name, it surely is no less a place name than any street road or motorway – while it is certainly longer than any road carrying vehicles at 615 miles in length.

The route is by no means a straight line, nor is it confined to Somerset. The route begins at Worcester, as did the man who gave the route its name, Charles II. On 3 September 1651, the King's forces had suffered a terrible defeat at the Battle of Worcester and, helped by several of his closest aides, Charles fled north intending to escape to the Continent. He famously spent many long hours in the Boscobel Oak at Shifnal in Shropshire with Colonel Carless, while the Parliamentarian soldiers were quite literally just below him.

The route enters Somerset at Keynsham having crossed the River Avon. Today the modern world means the original route cannot be followed and we are forced to detour

through Bristol. We know he spent the night of 12 September at Leigh Court at Abbots Leigh and the route leaves the county just south of Crewkerne.

After many adventures, Charles finally escaped to France on 15-16 October of that year, smuggled across the Channel in a coal boat named *Surprise*, which is pictured on the yellow waymarkers along the route.

MONKSILVER

Listings of this name include Selvere in 1086 and as Monkesilver in 1249. Here is a name which originally took the name of the river, itself from Old English *seolfor* or 'silver' and today we still refer to a clear, bright and sparkling river as 'the silver stream'. The addition from the fifteenth century is from Old English *munuc*, showing early possession by the monks of nearby Goldcliff Priory.

The local here is the Notley Arms, built in the middle of the nineteenth century. Its name comes from a local family, who first came to prominence when the Reverend George Notley purchased the estate at Combe Sydenham.

MONTACUTE

A place name found in Domesday as Montagud, this name comes from Old French *mont aigu* and describes 'the pointed hill'.

The local here is the Phelips Arms, which perpetuates an early spelling of the surname 'Phillips' and which is first seen in Thomas Phelipp who died in 1501.

MONKTON COMBE

This Old English place name is derived from the common Old English element *cumb* and refers to the '(place in) the valley'. Recorded as Cime in 1086, this name is given distinction by the addition of *mumuc tun*, the Saxon term for 'the farmstead of the monks'.

MOORLINCH

Here is a name recorded as Mirieling in 971, which can be seen as coming from Old English *myrge hlinc* or 'the pleasant ledge of land'.

MUCHELNEY

First found in 990 as Miclanige and as Muceleneia in 1084, this name refers to 'the large island'. This does not mean an island in the current sense, indeed, to the Saxons it could easily have referred to an area which remained dry in the wettest months when all around would be marshy.

MUDFORD

From Old English *muddig ford* or 'the muddy ford', this place name appears in Domesday as Mudiford. There are also the hamlets of Up Mudford, West Mudford and Mudford Sock – meaning 'higher', 'to the west', and from Old English *soc* meaning 'soaked, quagmire'.

MUDGLEY

The earliest surviving record of this name is as Mudesle in 1157. The first element is uncertain, probably a personal name, and is suffixed by the common Old English *leah* 'the woodland clearing'.

Chapter 13

Nailsea–Nynehead

NAILSEA

Surviving records of this name begin in 1196 with Nailsi. This features a Saxon personal name and Old English *eg* and speaks of 'Naegi's island, or dry ground in a marsh'.

NEMPNETT THRUBWELL

Here is a name which sounds as if it could never be found anywhere but Somerset. This place was originally two places, recorded as Emnet in 1200 and Trubewel in 1201, but as the two expanded they grew to become a single place and took on both names.

Nempnett comes from Old English *emnet* preceded by Middle English *atten* and describes 'the place at the level ground'. Early records of Thrubwell are few, thus while the suffix is undoubtedly Old English *wella* meaning 'spring or stream', the first element is very uncertain; however, perhaps this is a word related to modern 'throb' and thus referring to the 'gushing stream'.

NETTLECOMBE

A name found as Netelcumbe in Domesday, this is a name from Old English *nethel cumb* or 'the valley where nettles grow'. The minor name of Torre refers to 'the rocky hill' above the valley.

The hamlet of Woodford really does describe 'the farmstead by a wood', a simple name which it would not be a surprise to find many more of than there are.

NEWTON ST LOE

Found in Domesday as Niwetone and in 1336 as Nywetonseyntlou. Here is the 'new farmstead' from *niwe tun*, one of the most common place names in England and hence the addition. This is not the dedication of the church but shows early possession by the family of Roger de Sancto Laudo, who is recorded as lord of this manor in 1122. The place name of St Lo is derived from their homeland in the Manche region of France.

NORTHMOOR GREEN

A simple place name and one which is self-explanatory. However, there has never been a great population here and this may explain why this region is still referred to by this and two alternative names, Moorland and Fordgate, which are still found but refer to other locations close by. These alternative names, again simple and referring to 'the cultivated land on the moor' and the 'gap or gate by the ford' respectively, show how a place is normally named by the neighbours – to the inhabitants it is simply 'home'.

This settlement lies in a triangle formed by three A roads; there are numerous larger settlements found around here, Bridgwater, Westonzoyland, Middlezoy, Othery, Burrowbridge, and Durston to name but a few. All of these settlements would have known this place by some name; the three alternatives were the ones to survive to the present day.

NORTH NEWTON

Whilst there is no doubt this common name comes from Old English *niwe tun*, to give a definition of 'the new farmstead' is hardly correct, for there is a record of this place in Domesday as Newetune. Perhaps this should be given as 'the newer farmstead', although it is impossible to be sure which settlement was already here and thus the 'older' settlement. As it is such a common name, the addition is almost inevitable; here it tells us it was to the north of another of the same origin.

NORTHOVER

Found as Nordoure in 1180 and as Northovere in 1242, this name comes from Old English *north ofer* and describes the '(place at) the northern bank', this being the bank of the River Yeo.

NORTH PERROTT

A name recorded as Peddredan in 1050 and as Peret in Domesday, this takes its name from the nearby River Parrett, which is discussed under its own entry.

NORTH PETHERTON

A name found as Nordperet and also Peretune in Domesday, the basic name describing the '*tun* on the River Parrett'. This river name is dicussed under its own entry.

The river most likely provided the inspiration for the name of the pub, for although the White Swan can be heraldic, referring to Henry VIII and Edward III among others, it is an instantly recognised image and thus makes a good sign and name for a public house. Here we also find the Compass Tavern, a heraldic reference which appears in the coat of arms of three highly skilled workers: not the carpenters here, for that would be three compasses; nor is it the joiners, for they display two; this is the mark of the masons.

NORTH STOKE

With records of Stoch in Domesday and as Stoches in 1160, this place name comes from Old English *stoc* and refers to a 'special place'. This should not be seen as anything more 'special' than where a particular crop was grown or used only at certain times of the year. The addition is to distinguish it from South Stoke.

NORTH WOOTTON

Although recorded as Utone in 1086, we can dismiss this as an error. Domesday is notoriously inaccurate when it comes to recording proper names. However, the listing as Wodetone in 946 is enough to show this as from *wudu tun* and tells us it was 'the farmstead in or by a wood'. The addition is to distinguish this place from Wootton Courtenay.

NORTON FITZWARREN

As with the previous name, the basic name here is a common one. From Old English *north tun*, it does indeed refer to the 'northern farmstead', and is recorded simply as Nortone in Domesday. Later the place was held by the Fitzwarren family.

Here the local is the Ring of Bells, named in recognition of the excellent peal at All Saints church and a reminder of the long association between the community church and pub.

NORTON MALREWARD

In Domesday, it is found as simply Nortone; by 1238, it appears exactly as it does today. This is another 'northern farmstead', here with the addition of the name of William Malreward, a tenant working these lands for the Bishop of Coutances.

NORTON RADSTOCK

Another 'northern farmstead', this time associated with Radstock, a name discussed under its own entry.

Locally we find the name of Clandown, which is thought to come from *claen dun* or 'the clean hill'. Clean here is used in the sense not muddy, without obstacles.

NORTON ST PHILIP

Another Norton which, as with the previous name, describes 'the northern *tun* or farmstead'. Similarly, this was also recorded as Nortone in Domesday, with the later listing of Norton Sanctii Phillipi showing this addition refers to the dedication of the parish church.

NORTON SUB HAMDON

As with the previous two entries, this name is recorded in Domesday as Nortone in 1086; of course, this is again from Old English *north tun* and speaks of 'the northern farmstead'. The addition refers to its position under Hamdon Hill, the hill name from *hamm dun* 'the hemmed-in lands of the hill'.

NUNNEY

A name recorded in 954 as Nuni and as Nonin in Domesday. While it would be easy to give this as referring to a 'nun' or *nunne*, this would be a break from how we normally find such religious orders represented in place names. Hence the more likely beginnings are a Saxon personal name and *eg* and this 'Nunna's island or dry ground in a marsh'.

The local name of Holwell speaks of 'the spring in the hollow'. The Bear is a pub which likely takes its name from the so-called sport of bear-baiting, the animal being chained to a post and dogs set on it. This barbaric sport was made illegal in 1835.

NYNEHEAD

Found in the pages of Domesday as Nichehede, it is the earlier eleventh-century record of Nigon Hidon which makes the origins of this name clear. This name, from Old English *nigon hid*, tells us it was 'the estate of nine hides'. A hide, while often given as being equal to thirty acres, can never really be said to be a true measurement in the modern sense any more than 'tall' or 'narrow' can. A hide was the amount of land needed to support a family for a year, which clearly depended on several factors: the productivity of the soil, how good the growing season was, predation and/or disease, and not least the size of the family!

Chapter 14

Oake–Otterhampton

OAKE

Found in the early eleventh century as Acon and as Acha in 1086, this name comes from Old English *ac* in its plural form and offers few surprises as the '(place at) the oak trees'.

Within the parish is the quite recent name of Culbone, a recent name for what was formerly known as Kitnore, 'the hill slope frequented by kites'. The current name probably comes from the Culbone Stone, itself thought to be named from the St Columbanus, although the church is dedicated to St Bueno, of pre-Norman origin and one of the smallest in England seating about thirty at a service.

Culbone Woods were once home to a major charcoal-burning industry, said to have been run by a colony of lepers. Charcoal was a fuel used before coal was ever mined, produced by smouldering or slow-burning wood to remove moisture and impurities, this under a bank of earth and turf to exclude much of the oxygen and prevent combustion. This process took an experienced eye and a vigilant observer; boring as the task was, it had to be watched for as long as it took to ensure it remained alight but did not burn. To prevent the charcoal burners from sleeping on the job, they would be seated on a stool with just one leg, sleep would also bring them crashing to the ground and from this comes the phrase 'to drop off'.

The name of Hillcommon speaks for itself, for it really does mean 'the common land on or by the hill'.

OAKHILL

It is still obvious today that this name, from Old English *ac hyll*, describes 'the hill where oak trees grow'. The local pub takes the name, the Oakhill Inn's sign explaining the name of the place through simple imagery. The Oakhill Brewery, here in 1761, achieved fame through the production of Oakhill Invalid Stout.

Little London is an area at the western end of the village, applied to a region of a parish for some ironic reason which is no longer apparent.

OARE

Found in Domesday as Are, this place is named from the stream here which is now known as Oare Water, while there is also a region where the river was crossed now

referred to as Oareford. This is one of the oldest river names in England, is pre-Celtic in origin and is identical with the Aire in England, with Scotland's River Ayr, and European rivers known as the Aar, Ahr, Ahre, Ara, Ohre and Ore. While these early language groups had no written form, comparing the earliest records and with some knowledge of the way names evolve, we are able to define this as 'smooth running one', i.e., not turbulent. As rivers have always been of great importance to civilisation, it is possible to use these links to trace the theoretical Proto-Indo-European language which was the parent tongue to most languages of Europe and the Indian subcontinent.

The village of Oare features in R. D. Blackmore's novel *Lorna Doone*.

ODCOMBE

Found in Domesday as Udecome in 1086, this name comes from a Saxon personal name and Old English *cumb* and tells us it was 'the valley of a man called Uda'.

Odcombe was the birthplace of Thomas Coryate (1577-1617), who wrote a book on his travels through Europe and Asia entitled *Crudities*, in which he describes the way Italians shaded themselves from the sun and thus introduced the word 'umbrella' to the English language. He is also cited as the man who brought the table fork back to England from this journey.

The Masons Arms features the coat of arms of the Company of Masons, granted the right of a coat of arms in 1473.

OLD CLEEVE

This Old English place name is derived from Old English *clif* and refers to the '(place at) the cliff or bank'. Here the addition is self-explanatory and points to it pre-dating nearby Cleeve. Here also is Chapel Cleeve, a self-explanatory addition and part of which can still be seen in the Chapel Cleeve Hotel.

The hamlet of Leighland Chapel is from *leah land*, a name describing 'the cultivated land' where the addition is obvious. Another name here is Bilbrook, from Old English and describing 'the brook where billers or watercress grows'. The term 'billers' is a relic from a much earlier time which has held on here; it can be seen to be related to Gaelic *biolaire*, Irish *biolar*, Cornish *beler*, and Breton *beler*.

ORCHARDLEIGH

From Old English *orceard leah*, this name describes 'the garden or orchard in the woodland clearing'.

ORCHARD PORTMAN

The record from 854 as Orceard is the perfect spelling for the Old English term for 'an orchard or garden'. Thus, while today 'orchard' would only be used for 'fruit trees', in

the past it was clearly once a more general term referring to where food was grown. The addition here points to the lords of the manor, the Portman family being here by the fifteenth century.

The minor name of Thurlbear is found as Tierleberge in 1084, Torlaberie in 1086, and Turelberiz in 1219. This comes from Old English *thyrel beorg* and refers to 'the hill with a hole or hollow'.

ORCHARD WYNDHAM

A fairly late name not seen before 1424 when it was recorded as Orchard, again from Old English *orceard*. Here the addition refers to this manor being associated by one Johannes Wyndeham de Orchard in a document dating from around 1619.

OTHERY

Found as Othri in 1225, this name comes from Old English *other eg* and refers to 'the other island or dry ground in a marsh'. From this we can infer there were two islands and they were both associated with another unknown settlement.

A minor name here is Pathe, derived from Old English *paeth* and describing 'the pathway', a trackway used by those on foot. The local pub is the London Inn, a reminder from the days of the stagecoach of the destination of that route.

OTTERFORD

A name found as Oteriford in 854 and as Otriford in 1225, here is 'the ford across the River Otter' – a river name which indeed refers to that aquatic mammal.

OTTERHAMPTON

A name found as Otramestone in Domesday and as Oterhanton in 1180. This is nothing to do with otters but seems to come from 'Ottrane's *tun* or farmstead', however, the forms are too corrupt and rather late for any certainty.

Chapter 15

Parret–Pylle

PARRET (RIVER)

A name which was recorded as Pedridan in 658, Pedredistrem in 725, Pedredan in 894, Pedret in 1200, and Peret in 1233. This name is not only seen in Somerset but also in Dorset and formerly for tributaries of rivers in Gloucestershire and Worcestershire. Clearly, this must represent a term which was used in this part of England, one which has never been understood, and the origins of the river name remain unknown.

PAULTON

Here is a name which is first found in 1171 as Palton, a name from Old English *peall tun* and describing 'the farmstead on a ledge or slope'.

PAWLETT

Listed in Domesday as Pavelet and as Poulet in 1186, this would seem to feature two Old English elements *pal fleot* and refer to 'the tidal stream with poles or stakes'. This begs the question as to what these stakes are here for, the most likely answer being to mark a crossing point, perhaps one which was only below water when the tide was high. Suggestions that this may have been to prevent craft using the river to navigate inland seem unlikely, for there are numerous records that the river was used way beyond this point. Here River Road points the way to the river, and is the most likely place for the stakes to have been positioned.

Almost all the other road names here are self-explanatory: Quantock Rise is named after the hills, Vicarage Lane was not named such until the clergy lived here, similarly Chapel Lane leads to that place of worship and Manor Road to the old manor house. Bristol Road, the A38 trunk road, is the modern path, for originally it came through the village, as evidenced by the name of Old Main Road here.

PEASEDOWN ST JOHN

A name which descibes its location on the hill slope or 'down where peas are grown'. The addition, somewhat predictably, refers to the parish church dedicated to Saint John.

The Red Post Inn is an old coaching inn, which really was a red post and where the post boys exchanged mail in the coaching days.

PENSELWOOD

Records of this name include Penne in 1086 and Penne in Selewode in 1345. The basic name is from Celtic *penn* meaning 'hill'; the addition tells us it was 'in the wood where sallow trees grow', a name discussed under its own entry.

PENSFORD

The earliest record of this name dates from 1400 and is exactly the same as the modern spelling, which does not help in defining the name. The suffix here is clearly Old English *ford*, however, any thought that the first element is Celtic or British *penn* meaning 'hill' is unlikely. If we had further evidence, it would probably point to a Saxon personal name, something akin to the Saxon Penna or Penda.

PILL

A place name which is derived from the Old English *pyll* and which speaks of a 'tidal creek'. The place was previously known as Crockerne Pill, the former referring to the 'pottery wharf', which shipped from here, at least between 1100 and 1250, the readily identifiable Ham Green style, which has been traced by archaeologists as far south as Portugal and north to Iceland.

PILTON

Listings of Piltune in 725 and Piltone in 1086, this name is derived from Old English *pyll tun* and describes 'the farmstead by a stream'.

PITCOMBE

A place name recorded as Pidecombe in Domesday, this name comes from Old English *pide cumb* and describes 'the marsh of or in the valley'.

PITMINSTER

Domesday's record as Pipeminstre would suggest a slightly different origin to the earlier listing of Pipingmynstre in 938. However, while Domesday is undoubtedly a tremendous source of information, when it comes to proper names, it is notoriously unreliable. This is down to the survey being conducted by those who spoke Old French, while the information was provided by Saxons who spoke Old English. Even today the differences between French and German are obvious, and as most of the country were illiterate, the French phonetic spelling of Germanic proper names in Domesday are often markedly different from other records of the same name. Hence it is obvious the earlier record

is the more reliable and we can see this as a Saxon personal name and Old English *ing mynster*, giving 'the large church associated with a man called Pippa'.

PITNEY

Found in Domesday as Petenie, this name features a Saxon personal name and Old English *eg* and describes 'the island or dry ground in the marsh of a man called Pytta or Peota'. Clearly there are a lot of place names in the county with the suffix *eg* and a clear indication of the extant wetlands of the Somerset Levels.

PODIMORE

This name is probably derived from a combination of Middle English *pode* and Old English *mor*, together describing 'the marsh frequented by toads or frogs'. Perhaps this is not the best selling point for the Podimore Inn.

POLDEN HILLS

The oldest surviving records of this name date from the early eighth century. The most recent is dated 725 as Poeldune. The suffix here is Old English *dun* or 'hill'. Here the first element is seen in the other record from twenty years earlier, found as Bouelt, which is thought to refer to a 'cow pasture'.

POLSHAM

A name found as Paulesham in 1065, the year before the Norman Conquest and thus recorded by a Saxon hand. This can only be one of the earliest known references in England to the name Paul, here followed by Old English *hamm* and describing 'Paul's hemmed-in land'.

With the link between Somerset and the legendary King Arthur so strong, it is surprising that there are not more pubs named, as here, the Camelot Inn.

PORLOCK

With records of Portloca in the early tenth century and Portloc in Domesday, this name is from Old English *port loca* and aptly describes this location as 'the enclosure by the natural harbour'.

The sea has been rising steadily since the end of the last ice age seven or eight thousand years ago. Nowhere is it more apparent than the Bristol Channel with its large tides which expose great mud flats at their lowest ebb. Off the coast at Porlock, the petrified stumps and fallen trunks of trees which once grew here are periodically exposed, along with the bones of cattle and other wild animals killed by Mesolithic hunters in this heavily forested land. It is a sobering thought to reflect that what is now Porlock Beach was then five miles inland.

PORTBURY

From Old English *port burh* and recorded as Porberie in Domesday, this name tells us it was 'the fortified place by the harbour'.

 Local names include the Sheepway, which does indeed take its name from the track used by drovers bringing the sheep on and off the moorland.

PORTISHEAD

Listed as Portesheve in 1086, the Domesday record is the sole early form of note. However, despite Domesday's unreliability in the spelling of proper names, this can still be seen as coming from Old English *port heafod* and meaning 'the headland by the harbour'.

PRESTON PLUCKNETT

A name recorded as Prestetone in Domesday and as Preston Plukenet in 1285, the basic name coming from Old English *preost tun* or 'the farmstead of the priests'. The addition here is from the family of Uhtred and his son Richard, who held this manor by the thirteenth century.

PRIDDY

An unusual-sounding name, which can be attributed to it not being Old English. Recorded as Prisia in 1182, this is from Celtic or British *prith liz* and describes 'the earth house'. Such tells us here was a building where the framework was constructed of wood and possibly stone, thereafter covered with turf to provide an excellent insulation – not to mention blending in with the landscape. Such a name is a particular favourite of the author, for it paints a picture of everyday life in England, providing a snapshot no camera could have taken and no artist would have felt it necessary to record.

 Local names include the Hunters Lodge Inn, taking its name from that found on an old map of the place, while the New Inn, quite simply, was named more recently.

PRISTON

Found as Pristun in 931 and as Prisctone in 1086, this name combines Old English *tun* with a British or Celtic word related to Old Welsh *prisc* and describes 'the farmstead near the brushwood or copse'.

PUBLOW

A name listed as Pubelawe in 1219, as Pubbelowe in 1259, and Puppelawe in 1262. Here is a Saxon personal name followed by Old English *hlaw* and describing 'Pubba's barrow'.

PUCKINGTON

The only record of note comes from Domesday as Pokintuna, thus derived from a Saxon personal name and Old English *ing tun* and telling us it was 'the farmstead associated with a man called Pica'.

The hamlet of South Bradon is recorded numerous times in the eleventh, twelfth and thirteenth centuries, including Bredde, Brede and Bredene in Domesday alone. While the addition is to distinguish this from nearby Goose Bradon, the basic name is uncertain, for the forms are too similar to show the evolution of the name and could have one of several meanings.

PURITON

A name found in 1212 as Piriton, however, it is the earlier Peritone in Domesday, which is of more interest. The great tome shows this is the only place in the land which was a possession of St Peter's in Rome, the papacy being given this manor as a 'thank you' for having supported the Conquest in 1066. Domesday also records there were a number of pear trees growing here, which is also the reason for the name – from Old English *pirige tun*, this is 'the farmstead where pear trees grow'.

PUXTON

Pukerelston is the earliest record to survive, dating from 1212. This features an Old French surname with Old English *tun* and describes 'the farmstead of the Pukerel family'.

PYLLE

Records of Pil in 705 and Pille in 1086 show this comes from Old English *pyll*, a word used to describe a 'tidal creek'.

The local pub remembers the most influential family in the village in recent times, the Portman Arms remembers the family who rebuilt the church dedicated to St Thomas à Becket in 1868. This family have been associated with this area since the sixteenth century, even giving their name to nearby Orchard Portman.

Chapter 16

Quantock Hills–Queen Charlton

QUANTOCK HILLS

As with so many natural features in the landscape, this is derived from the Celtic or British language and is recorded as Cantucuudo in 682. This language has no written form and can only be understood by comparison with other related languages which have endured to the present day, such as Welsh, Cornish and Breton. Thus this is seen as being derived from the element *canto* and maybe used to mean 'border or district'. While this explains the modern form, that of the seventh century seems to have acquired Old English *wudu* or 'woodland'.

QUANTOXHEAD (EAST AND WEST)

Recorded in Domesday as Cantocheve, these places share an origin of 'the projecting ridge of the Quantock Hills' where the Celtic hill name has been suffixed by Old English *heafod*.

At West Quantoxhead, the local hostelry is the Windmill, a name chosen as much for its simple and easily recognised image as for reflecting the former position of the same.

On the coast here is the bay known as St Audrie's, also a name by which West Quantoxhead is still sometimes known. This comes from the estate which in turn took its name from the parish church dedicated to St Ethelreda, also known as St Audrey.

QUEEN CHARLTON

This Old English place name is derived from *ceorl tun* and refers to this as 'the farmstead of the freemen or peasants'. The addition is found from the sixteenth century when it was given to Queen Catherine Parr by Henry VIII. It is recorded as Cherleton in 1291.

Chapter 17

Radstock–Runnington

RADSTOCK

Here is a name which is first found in 1086 as Stoche, while by 1221 this has become Radestok. This comes from Old English *rad stoc* and describes 'the outlying farmstead by the road', the road in question being the Fosse Way.

The origin of the name of the Tuckers Grave Inn is even more macabre than it sounds. Tucker was a local man who committed a dreadful sin, he took his own life. He was found hanging in a barn near the inn and, as was the custom of the time, was denied a burial in consecrated ground. It is rumoured that ground is now occupied by the pub's car park.

The Fir Tree Inn is one of the many 'tree' names for a pub, often pointing out a large and imposing tree which would act as a natural signpost to the pub. The Jollife remembers the family who were highly influential here by the end of the eighteenth century. The Tyning Inn shares its name with one of the pits on the Somerset coalfields, although the origins of both are uncertain.

REDCLIFF BAY

It is still quite obvious this name comes from Old English *read clif* and describes 'the red cliff or bank'. This name is found in a document from around 1180 as Radeclive.

REDHILL

Domesday's record of Ragiol shows this to be from Old English *ra ecg hyll* and tells us this was 'the hill at the edge where roe deer are seen'.

As obvious as the origins of the parish name is, that of Downside is probably even more so, referring to the 'slope of the hill'.

REDLYNCH

Found as Redlisc in Domesday, this name comes from Old English *hreod lisc* and describes its location by 'the reedy marsh'.

RIMPTON

A name found in Domesday as Rintone, although it is the earlier record of Rimtune in 938 which is of interest here. This name comes from Old English *rima tun* and means 'the farmstead on the boundary'.

What began as a local landmark, the White Post Inn is now a larger landmark and much easier to see.

ROAD

Found in 1086 as Rode, in 1201 as Roda, and in 1230 as La Rode, this place comes from the Old English *rod* referring to a man-made clearing. The number of mills here is reflected in the name of the local pub, simply known as the Mill.

ROADWATER

This name comes from Old English *rod* 'clearing' while the second part refers to the Washford River, where there were a large number of mills operating during the eighteenth and nineteenth centuries.

ROCKWELL GREEN

A name which probably comes from 'Hroc's spring or stream' and where the reference to the village green is a fairly recent addition.

This was where the steam locomotive *City of Truro* reached as important a milestone as any in the industrial age. For the first time ever, man travelled at a speed of one hundred miles per hour, recorded as it passed beneath the bridge here. It was pulling a mail train from Plymouth to Paddington on 9 May 1904.

RODNEY STOKE

A name found as Stoches in Domesday, this comes from Old English *stoc* and refers to the 'outlying settlement'. The addition here is a reminder of the de Rodeney family, here by the fourteenth century.

Here is found the hamlet of Nyland, a name which is found as Ederedesie in 725 and as Adredesia in 1344. Here the original name referred to 'Eadred's island', while the present name comes from Old English *ieg land* and simply 'the island'. Many place names beginning with a vowel in Old English have acquired an initial 'N' from Middle English *atten* or 'at the', when the final letter has mistakenly migrated from the end of one word to the beginning of the following word – hence *atten iegland* evolved to 'at Nyland'. The name of Bradley Cross shows it was at a crossroads or meeting point and one which was already called 'the broad woodland clearing'.

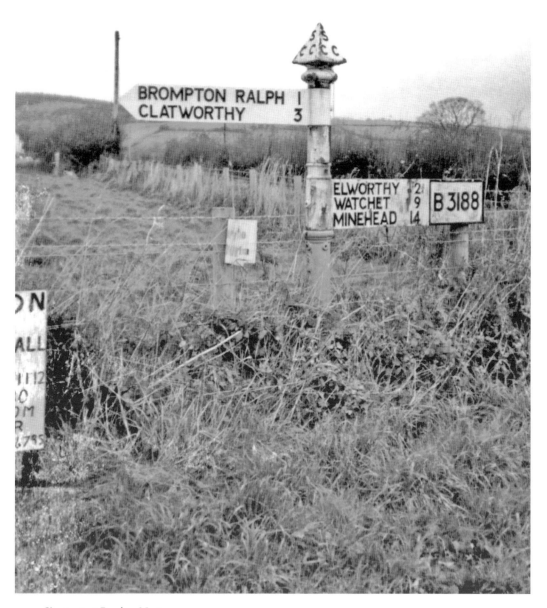

Signpost at Rookes Nest

ROWBERROW

With records of Rugebera in 1177, Ruberga in 1194, and Rugeberg in 1227, this name is easy to define as 'the rough hill' from Old English *ruh beorg*.

RUISHTON

Recorded as Risctun in the ninth century, this comes from Old English *rysc tun* and describes 'the farmstead where rushes grow'. The name was also passed on to the Ruishton Inn.

RUNNINGTON

Found as Runetone in 1086, this is the 'farmstead of a man called Runa' where the Saxon personal name is followed by Old English *tun*.

St Catherine–Swainswick

ST CATHERINE

A small village in the north of the county which takes the name of the twelfth-century church. The church stands in the grounds of the sixteenth-century St Catherine's Court, a Tudor manor house and Grade I listed building which was purchased by actress Jane Seymour in 1984 and extensively refurbished.

ST CUTHBERT OUT

A district name given to the area which entirely surrounds the city of Wells, yet does not include it. The name, somewhat predictably, refers to 'that region outside the city associated with St Cuthbert'.

Dulcote is found here too, a name derived from 'Dulla's cottages'. Worminster has been influenced by the connection with nearby churches, for this is not a 'minster' but comes from Old English *wyrm tor*. However, how this is understood is debatable, for this could be a personal name or a nickname and thus 'Wyrm's hill', or perhaps this is used in the sense of 'snake' or even 'dragon'.

ST GEORGES

A modern parish, one which clearly takes its name from the dedication of the church. The area has been developed recently, providing much needed new housing in the area.

SALTFORD

A name found as Sanford in 1086, as Salford in 1229, and as Saltford in 1291. This seems to be referring to the 'salt water ford', from Old English *salt ford* but could be *salh ford* and thus the 'sallow or willow ford'.

SAMPFORD ARUNDEL

From Old English *sand ford* comes 'the sandy ford'. Recorded as Sanford in 1086, the record of Samford Arundel in 1240 shows this manor was held by the family descended from Roger Arundel, who had been here at the time of the Domesday survey.

Locally we find the name of Bagley Green; this last element is a comparatively modern addition referring to the 'bag-shaped woodland clearing'.

SAMPFORD BRETT

Recorded as Sanford in 1086 and as Saunford Bret in 1306, as with the previous name, this is 'the sandy ford' and was the manor of the Bret family, here in the thirteenth century.

SANDFORD

A name which can still be seen as describing itself as 'the sandy river crossing'. Similarly the local pub is the Railway Inn, clearly named after the railway although the Cheddar Valley Line has not run for several years.

SEAVINGTON (ST MICHAEL & ST MARY)

Records of this name are found from 1025 as Seofenempton and in Domesday as Sevenehamtune. This name comes from Old English *seofon ham tun* and describes 'the village of the seven homesteads' and obviously originally was applied to just one of these places. The two have distinguishing additions from the dedications of the respective churches.

At Seavington St Michael the local is the Volunteer Inn which, while it could refer to any regiment which encouraged volunteers, invariably refers to those who set up a defence force at home in the Napoleonic Wars, the Local Defence Volunteers of the First World War, and the Home Guard in the Second World War.

SELWOOD

The earliest record of this name dates from 894 as Seluudi, a name which comes from Old English *sealh wudu* and speaks of 'the wood where sallow trees grow'.

Locally we find the minor names of East Woodlands and West Woodlands, self-explanatory names showing this was heavily wooded before the area was quarried. The hamlet of Alder Row really does refer to 'the row of alder trees', a clearly artifical feature which was most likely an avenue of trees or perhaps marking a border.

SELWORTHY

Domesday records this name as Seleuurde or 'the enclosure by the copse of sallow trees' from Old English *sele worthig*.

The minor name of Lynch is first found in 1259 as Linz and later as Lynche in 1325, this comes from Old English *hlinc*, meaning 'ridge, ledge'. Bossington is derived from 'the farmstead of the family or followers of Bosa'.

SEVERN (RIVER)

Records of this major river go back a long way, indeed they are found as early as the second century AD as Sabrina, with later forms of Saberna in 706, Saeferne in 757, be Saefern in 910, Saverna in 1086, and Severne in 1248.

It is the longest river in Britain at 220 miles and drops 2,000 feet from its source in Plynlimon in Wales and has the greatest water flow of any river of the mainland. An important route into the heart of England and Wales since man repopulated Britain at the end of the last Ice Age it has, together with its many tributaries, been a natural boundary between England and Wales, if not an actual border. Navigable upstream as far as Welshpool, it is tidal as far as Gloucester Docks. The lower reaches of the Severn are the scene of a phenomenon known as the Severn Bore, a wave of up to 7 feet in height and the product of a tidal range of 49 feet coupled with the funnelling effect of the Severn Estuary.

Such a large and important river has attracted a great deal of attention since mankind first saw its waters, not only from practical but also religious and ritual purposes. In its higher reaches, the river is associated with Sabrina, as seen in the earliest record of the name, also known as Hafren and a deity or water spirit said to have drowned in the river. The Welsh name for the river, the Afon Hafren, is derived from this Celtic deity, while the Latin version of this name is Sabrina. The same deity is seen in Ireland, where the old name of the River Lee through Cork was the Sabrann. Perhaps this is the basis for the name of the Severn. However this does not explain why the lower Severn, the tidal reaches below Gloucester, is where the river is associated with Noadu (Nodens to the Romans) who is depicted riding a seahorse and riding the crest of the Severn bore.

SHAPWICK

A name which is derived from Old English *sceap wic* 'the farm which specialises in rearing sheep', the place recorded as Sapic in 725 and as Saleswich in 1086.

SHARPHAM

A name which is derived from Old English *scearp hamm* and describes 'the steep hemmed-in land'.

SHEPTON BEAUCHAMP

Found in Domesday as simply Sceptone and as Septon Belli Campi in 1266, this basic name is derived from old English *sceap tun* 'the sheep farmstead'. The addition here is manorial, derived from the Beauchamp family, who were here by the thirteenth century.

The local is the Duke of York, which could refer to any of those who held this title since its creation in 1385. As with the current holder, Prince Andrew, it is held by the second son of the monarch on the occasion of his marriage.

SHEPTON MALLETT

As with the previous name, this is 'the sheep farmstead', here recorded as Sepeton in 1086 and as Scheopton Malet in 1228. The addition here refers to the lords of the manor from the twelfth century, the Malet family.

The Market Cross, Shepton Mallett

The Highwayman, Shepton Mallett

Local pubs include the Three Horseshoes, an advertisement showing there would have been a blacksmith available at this inn, one where travellers could rest while their horse could be shod. The Downside Inn is a place name, taken from the slope on which it is located. The Natterjack Inn was once the Railway Inn, however, the present name was adopted in 1976, Conservation Year, when it was chosen to represent the increasingly rare natterjack toad. The Strode Arms takes its name from the family who came to the town from that place near Ivybridge, in Devon.

The streets of the town reflect the history too. Market Place needs no explanation, neither does the splendid market cross which was erected here around 1500 by Agnes Buckland in memory of her late husband Walter. No charge was ever to be levied on the traders who sold their goods from here, so farmers were eager to take advantage of its shade to sell perishable goods. Over the years, eggs, milk, butter, cheese, cockerels and fish have been on offer to the locals. The building known as the Bread Room was where loaves and soup were distributed to the poor; it stands near Strodes Almshouses which were a gift from the Strodes family, local clothiers.

Martins Lane is the local name given to a public footpath. Clearly it must have been associated with a man called Martin at some time, however, the name of this right of way is known throughout the land, for this marks the route of the Roman road called the Fosse Way. Waterloo Road and Waterloo Road Bridge were opened in 1825 and renamed to commemorate the tenth anniversary of one of the most famous battles of all time.

SHEPTON MONTAGUE

Yet a third 'sheep farmstead', as with the previous two entries, this name is recorded as Sceptone in 1086 and as Schuptone Montagu in 1285. Again the addition is manorial, referring to the tenant Drogo de Mantacute who was here by 1086. The local pub also remembers this family as the Montague Arms.

SHIPHAM

A place name found in Domesday as Sipeham and in 1291 as Schepham. This comes from Old English *sceap ham*, 'the homestead associated with sheep' or perhaps 'shepherds'.

SHOSCOMBE

A name which seems to describe 'the valley of the evil spirit' from Old English *sceocca cumb*. This first element may represent a nickname, derived from the same word and one which was probably used humourously.

SHURTON

The earliest surviving record is from 1219 as Sureveton; this comes from Old English *scir refa tun* and describes 'the sheriff's manor'.

SIMONSBATH

Here is a name from two distinct and quite separate eras. The later addition of *baeth*, not seen before 1791, refers to 'water, a pool'. However, the original name must have had a different suffix, although no record survives, for originally this was 'Sigemund's place'.

Suggestions that this name refers to a Simon, a great hunter and Robin Hood-style hero who was abroad in the West Country during the Middle Ages is down to seventeenth-century literature. In fact, Simon was probably no more or less real than Robin Hood and several other legendary heroes of England.

SKILGATE

Domesday records this place as Schiligata, a name which can still be seen as coming from Old English *scilig geat* and describing 'the stony or shaly gate or gap'.

SOHO

As with its more famous namesake in London, this place is derived from a hunting cry, an alert that the prey had been identified. However, there is also the story that this was the secret password used by the supporters of the Duke of Monmouth, those who backed the failed attempt to overthrow the newly crowned James II. Monmouth's claim was never going to be successful; he was the eldest illegitimate son of Charles II and, following defeat at the Battle of Sedgemoor in 1685, was executed along with many of his supporters.

SOMERSET

The name of the county is seen in the twelfth century as Sumeraeton, a name meaning 'the dwellers around Somerton' and featuring a reduced form of Somerton with Old English *saete*.

SOMERTON

This is almost certainly derived from Old English *sumor tun* and describes 'the farmstead only used in summer'. The place is listed as Sumortun in 901 and Summertone in 1086.

Two of the simplest and most easily recogised images are seen on the signs of the pubs here, leading to the names of the Globe Inn and the Half Moon Inn.

SOUTH PETHERTON

Records such as Sudperetone in 1086 show this to describe 'the farmstead on the River Parrett'. This river name is discussed under its own entry.

SOUTHSTOKE

A common place name which comes from *stoc* and refers to 'the outlying place'. This name is recorded as Tottanstoc in 961 and Sudstoca in 1156, where the tenth-century record shows this was 'Totta's outlying place', and by the twelfth century, this had become 'the southern outlying place'.

SOW (RIVER)

A river name which comes from an uncertain British word; all the references are too late to be considered as suitable evidence.

SPARKFORD

Look in Domesday and, although the original is written in Latin, it is still possible to recognise the record of Sparkeforda. This comes from Old English *spearca ford* and describes 'the brushwood ford'. For those travelling here from outside the village, they were left in no doubt as to where they had enjoyed a drink by naming the place quite simply the Sparkford Inn.

SPAXTON

The earliest surviving record is from Domesday as Spachestone, which points to this being from 'the *tun* or farmstead of a man called Spakr'. This is an Old Scandinavian personal name, however, this does not suggest the person was of Scandinavian origin or even descended from there. Whilst this is a possibility, it may have been someone simply liked the name.

The Lamb Inn is a reminder of the Lamb Brewery at Frome.

STANTON DREW

The basic name is a common one, hence the addition for distinction, from Old English *stan tun*, and describes 'the stony farmstead'. The name is recorded as Stantone in 1086

and Stanton Drogonis in 1253, the latter showing this manor was held by Drogo, also known as Drew, in 1225.

STANTON PRIOR

Found as Stantune in 963, Stantun in 965, and Staunton Prior's in 1276, this name comes from Old English *stan tun* and describes 'the farmstead on stony ground'. The addition, first found in the thirteenth century, shows possession by the Prior of Bath.

STAPLE FITZPAINE

A name recorded as simply Staple in Domesday, the basic name is not uncommon and is derived from old English *stapol*, describing '(the place) with a marker post'. The addition is manorial, referring to the Fitzpaine family who were here from the fourteenth century.

The local is the Greyhound Inn, probably named from a former landlord or owner who kept or bred the animals for hunting, such as in hare coursing.

STAPLEGROVE

Found in 1327 as Stapilgrove, this name is derived from the Old English *stapol graf* and describes the 'woodland grove where posts are obtained'. There are two possible meanings here, either this refers to a managed woodland, where trees are pollarded to produce long straight poles used in building, or more likely, this was a lumber yard where these were brought having been gathered from pollarded trees around here.

STATHE

The earliest record of this name is from 1233 and is exactly the same as today. This comes from Old English *staeth* describing 'the landing place' and clearly was a regular point for loading and unloading from the river even before the canal came through here.

STAWELL

Recorded in Domesday as Stawelle, this is from Old English *stan wella* and describes 'the stony spring or stream'.

Sutton Mallet is another 'southern farmstead or *tun*'; here the manor was held by Ralph Malet by 1200.

STAWLEY

A name which appears as Stawei in Domesday, as Stauleyg in 1236, and as Stanlegh in 1243. The last of these is the closest to the original Old English *stan leah* 'the stony woodland clearing'.

Within this parish is the hamlet of Appley, from *aeppel leah* or 'apple tree clearing'. The name of Kittisford, found as Chedesford in 1086, as Kedeford in 1236, and as Kydesford in 1327, is derived from 'Kitti's ford'.

STOCKLAND BRISTOL

From Old English *stoc land* and recorded as Stocheland in 1086, this is 'the outlying farmstead of cultivated land'. The addition shows this was a possession of the chamber of Bristol.

Local names include Steart, the village taking its name from Old English *steort* referring to the 'promontory' on which it stands.

STOCKLINCH (MAGDALEN AND OTTERSAY)

Records of this name are found as Stoche in 1086, Stokelinges in 1196, Stokelinz in 1201, Stok in 1243, Stokelinz Ostricer in 1257, and Stokelynche Magdalene in 1349. The basic name comes from Old English *stoc hlinc* and describes 'the outlying farmstead of or by the hill'. The additions here refer to the dedication of one church to St Magdalen, while the other remembers the family who were here in the twelfth century. William Austurcarius shows the Latin version of a family which included John le Ostricer, a name which comes from Middle English *ostreger*, Old French *ostruchier*, and Latin *austurcarius*, which all refer to the man's job as 'keeper of goshawks'.

STOFORD

Found as Stafford in 1225, this comes from Old English *stan ford* and describes 'the stony ford'. Normally we would expect this to have evolved to 'Stanford' and that it has not is entirely due to local pronunciation.

The local here is the Royal Oak, the second most popular pub name in the country and one which can trace its origins back to the oak tree in which Charles II hid after his defeat at the Battle of Worcester in 1651.

STOGUMBER

As with the previous entry here is a name which has evolved rather unusually because of local pronunciation. Indeed, the thirteenth-century record of Stoke Gunner is exactly as we would expect it to be today, considering the origins of this place name. From Old English *stoc* or 'outlying farmstead' is added the surname Gumer, that of an early owner of this manor.

Here we find the minor name of Escott or 'the eastern cottages', while Higher Vexford is shown as Fescheforde in Domesday and is identical with Freshford in describing a 'crossing over a non-tidal river'. Kingswood means exactly what it says, this is indeed 'the woodland possessed by the monarch'. Preston is a common name and always refers to 'the *tun* or farmstead of the priests'.

STOGURSEY

Recorded as Stoche in 1086 and as Stok Curcy in 1212, this *stoc* or 'outlying farmsterad' was held by the De Curci family, who were first recorded here in the twelfth century as resident in the castle, the ruins of which are still visible.

The local name of Stolford likely comes from Old English *stigol ford* or 'the ford reached via or near a stile'.

Here is the White Horse Inn, a heraldic name which refers to the House of Hanover.

STOKE ST GREGORY

Another place name featuring *stoc*, not surprisingly the most common place name in England. Here the 'outlying farmstead' takes the name of the dedication of the church to distinguish it from the many other places called Stoke.

Clearly an early landlord at the Rose & Crown was keen to declare himself a patriot.

STOKE ST MARY

Listed as Stoc in 854, Stoce in 882, and Stocha in 1086, this name describes the *stoc* or 'outlying farmstead'. The addition, predictably, shows the dedication of the church to St Mary.

STOKE ST MICHAEL

Another Old English *stoc* or 'outlying farmstead', this time the church being dedicated to St Michael.

The local pub here is the Knatchbull Arms, the family name of the lords Brabourne who have been associated with the area for many years.

The locals here like to refer to a small tributary of the Nettlebridge Stream as 'the Stream With No Name', for this is perfectly true. No surviving map, document or memory gives any clue as to the name of this stream. The Knatchbull Arms, named after the family who were lords of this manor, had previously been the Stoke Inn and before that the Admiral Matthew.

STOKE SUB HAMDON

A place name recorded as Stoca in 1086 and another found to come from Old English *stoc* or 'the outlying farmstead', most often where a farming community made their temporary home during the busiest times of the growing season in order to feed the growing community. By 1248, the place had become known as Stokes under Hamden, the addition referring to Hamdon Hill, a name discussed under its own entry.

STOKE TRISTER

Recorded in Domesday as Stoche and as Tristrestok in 1265, and as Stoketristre in 1304, this name is another *stoc* or 'outlying farmstead'. Here the addition has never been clearly understood, it is possibly manorial derived from the del Estre family.

STON EASTON

This Old English place name is derived from *east tun* or 'the farmstead to the east'. It is a common place name and is normally found, as here, with a second defining element. Here this comes from *stanig* and is a reference to 'the stony ground'.

STOWELL

A place name recorded as Stanwelle in 1086, the place name coming from Old English *stan wella* and describing 'the stony spring or stream'.

STOWEY (NETHER AND OVER)

The record in Domesday of Stawei points to an origin of Old English *stan weg* or 'the stony way or road'. This refers to a naturally stony path, not one which has been created, for that would have a different origin as we shall see in the next entry, and one which would have been most welcome in the wetlands of the Somerset Levels. The additions for these closely linked places refer to them as 'lower' and 'higher' respectively.

At Nether Stowey is Coleridge House, home to the Romantic Poet Samuel Taylor Coleridge for three years, which is commemorated by Coleridge Road. He often took walks from there to Porlock and the route he took is now marked out as the Coleridge Way. He wrote the most famous work here, *The Rime of the Ancient Mariner*, hence the name of a local pub, the Ancient Mariner. The village location was also the inspiration for the Cottage Inn.

Coleridge invited his friend and fellow poet William Wordsworth to share the delights of this part of Somerset and he rented a place in Holford. The two developed a friendship with Tom Poole, the local tanner, who is remembered by streets named Tanyard and Pooles Close. Castle Hill and Castle Street take their name from Stowey Castle.

STRATTON ON THE FOSSE

A name recorded as Stratone in Domesday, which is derived from the Old English *straet tun* or 'the farmstead on the Roman road'. This name, unlike the previous entry, refers to a made road and not a naturally stony way. This addition shows it lies on the famous Fosse Way, a Roman road which was not named by the Romans but is derived from Old English *foss*, the Saxon word for a 'ditch'. Whilst Roman roads are renowned for being well built from several layers of stone, making them hard-wearing and an all-weather surface, an equal improvement existed alongside in the form of the drainage ditch. Channelling water away from the road made it last much longer and would have been seen as a revelation by the Saxons.

The hamlet of Nettlebridge refers not to a bridge but to a ridge. From Old English *netlen hrycg* comes 'the ridge of nettles'.

Local pubs include the Kings Arms, a declaration of support for the monarchy, and the White Post Inn which would have been a marker and signpost.

STREET

As seen in the previous name, this place is derived from its close proximity to a Roman road. Here Old English *straet* meaning 'Roman road' is first recorded in 725 as Stret.

The place name is also seen in the Street Inn, while a prominent local tree gave its name to the Elms Inn.

East Lane seems, on the face of it, to be a most inaccurate name, for it is found on the extreme west of the town. However, a glance at a more detailed map shows the fields alongside were Eastfields which, quite logically, were to the east of Westfields. Teetotal Row is still without a single pub or club, Horspool Lane marks where horses have been watered for centuries, and Lovers Lane may not have been the actual place for courting couples but offered the opportunity in the form of shaded places and a quiet location.

STRINGSTON

A name recorded as Strengestune in 1086, this Domesday record helping to show this is from a Saxon personal name and Old English *tun* to describe 'the farmstead of a man called Strenge'.

SWAINSWICK

The earliest known record of this place name is as Swyneswyk in 1291. This early record shows an origin from Old English 'Svein's *wic* or specialised farm'.

Chapter 19

Tatworth–Twerton

TATWORTH

A name derived from a Saxon personal name and Old English *worth* to tell us of 'Tata's enclosure'. There is also the local name of Forton, a common name describing 'the farmstead by the ford'.

One of the pubs here is the Poppe Inn, a name which doubles as an invitation.

TAUNTON

Found as Tantun in 737 and as Tantone in Domesday, this name is surely derived from 'the *tun* or farmstead on the River Tone'. This Celtic river name is discussed under its own entry.

The local name of Holway is a little different from the normal Holloway but means exactly the same. The constant passage of feet, hooves and wheels over muddy roads for centuries wears away the topsoil and produces a pronounced hollow, hence the name of 'the hollow way'. Wilton comes from *wiell tun*, the Old English for 'the farmstead by the spring or stream'. As Saxon society was largely agrarian and required a reliable source of fresh water, the only surprise in this simple name is that there are not many more Wiltons in England.

Many pubs are named to mark a particular trade, be it the former occupation of the owner or landlord, or an invitation to those employed in such areas. In Taunton, we find the Master Thatcher, Gardeners Arms, Pen & Quill, and Naval & Military. Names which show support for the monarch and the nation include the Royal Oak Inn, Queens Arms, Royal Crown, and the Perkin Warbeck, the pretender to the throne during the reign of Henry VII. The Vivary Arms takes its name from the area of the old estate given over to lakes and fishponds and a name shared with the park and road. The Flying Horse is a name which can be traced back to the insignia of the Knights Templar; the Black Horse and White Horse Inn also feature heraldic symbols. Other buildings are marked by the names of the Old Library, and the Ring of Bells which refers to the peal from the nearby church.

Twinned with Lisieux in France, the event is commemorated by Lisieux Way. In the town of Lisieux in northern France, there is a Rue de Taunton.

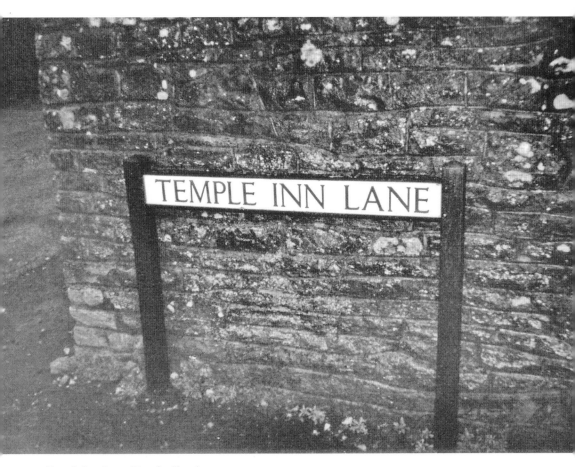

Temple Inn Lane, Temple Cloud

TELLISFORD

A name recorded as Tefleford in 1001 and appearing as Tablesford in Domesday. There have been suggestions that the first element here may be the Saxon personal name Theofol, however, this does not seem to fit with the Domesday record. While the great tome's reliability when it comes to proper names is often questionable, this might be an example of where Domesday helps in choosing between two alternatives. Here, if this is from Old English *tefli ford*, then it speaks of it being 'the ford at a flat or level place', a name which fits rather well with the Domesday record of Tablesford.

TEMPLE CLOUD

This Old English place name is recorded as La Clude in 1199 and is derived from Old English *clud* or 'the rocky hill'. The addition, while it is not recorded as such, most likely refers to lands held by the Knights Templar.

TEMPLECOMBE

As with the previous name, this common place name element has taken an addition from an association with the Knights Templar. From Old English *cumb*, this is the '(place in) the valley' and recorded as Come in 1086 and Cumbe Templer in 1291.

Within the parish we find the name of Combe Throop: here the *cumb* or 'valley' is seen again, this time with the addition of *thorp* or 'outlying settlement'.

The local is the Royal Wessex, named after the steam locomotive which is also featured on the pub sign.

THEALE

A name found in a document from 1176 as Thela, and one which is from Old English *thelu* and refers to 'the planks'. Unfortunately, there is no second element and thus it is impossible to say what this cut wood was used for; however, it is tempting to suggest this may have been a storage place and the wood could have been utilised for one of the raised wooden causeways which enabled travel across the Somerset Levels.

One example of such is the Sweet Track, named after the man who discovered it, Ray Sweet. This track runs for a distance of just over a mile and is one of the oldest engineered roads ever discovered, dendrochronology dating it at 3806 BC, which makes it the oldest wooden trackway known in Northern Europe.

THORNE ST MARGARET

A name recorded as simply Torne in Domesday and one which comes from Old English *thorn* describing the '(place) at the thorn tree'. By 1251, the place name includes the dedication of the church as shown by the record of Thorn St Margaret. The religious theme is continued by the name of Holywell Lake, speaking of 'the holy spring'.

THORNFALCON

As with the previous entry, the early form is recorded in Domesday as the '(place) at the thorn tree' from Old English *thorn*, although the record in the great work interprets this as Torne. By 1265, the name is found as Thorn fagun, the addition being manorial and showing this was held by the Fagun family.

THURLOXTON

The earliest surviving record of this name comes from 1195 as Turlakeston. Here the Old English *tun* follows an Old Scandinavian personal name and describes 'Thorlakr's farmstead'. The Scandinavian link is unlikely to be anything more than a name, although it is not impossible to find a person with this heritage so far south and west.

The pub here is the Maypole Inn, named to remind us that the pub and the village green were the focal point for the annual May Day celebrations when villagers would dance in intricate patterns with coloured streamers attached to a pole. The origins of such are unclear but it is deemed to be pre-Christian.

TICKENHAM

Domesday's record of Ticaham is the only early record of note, which makes deciding between the two potential origins difficult. If the first element is a Saxon personal name, then the suffix is Old English *ham* and this is 'Tica's homestead'. However, if the first element is *ticcen*, then this is followed by *hamm* and speaks of 'the hemmed-in land where goats are kept'.

The name of the Star Inn may either be a reference to the church or, more likely, the badge of the Worshipful Company of Innholders.

TIMBERSCOMBE

No doubts as to this place name, this is from Old English *timber cumb* and describes 'the valley where timber is obtained'. The name is recorded as Timbrescumbe in Domesday.

TIMSBURY

More than just a passing similarity between this and the previous entry, they share the first element *timber*, although here it is followed by *bearu*. These are Old English words describing 'the woodland grove where timber is obtained'. However, unlike the previous entry, this is more likely to refer to where timber was held rather than where it was cut, for a grove would not be a sustainable resource for long enough to enable the name to stick. The name is found as Timesberua in 1086 and as Timberesberwe in 1233.

The very early days of mining are remembered by the name of the local pub, the Guss and Crook. A look at the sign shows a miner on hands and knees, a rope tied around his waist (the guss) attached to the truck by a 'crook' which he is hauling along underground.

TINTINHULL

A name found as Tintanhulle in the early tenth century and as Tinenella in Domesday. This features three elements from two languages; the last is Old English *hyll* and was added as the Saxons did not see any relevance in the old Celtic name. This is still the case today, for although the first element is undoubtedly *din* 'hill fort' the second has never been understood.

The Crown & Victoria Inn shows the landlord to be a patriot; however, this combination is highly unusual and seems to suggest this is an amalgamation of two pub names.

TOLLAND

Found in the pages of Domesday as Talanda, here is Old English *land* describing 'the cultivated region by the River Tone'. This is a Celtic river name discussed under its own entry.

TONE (RIVER)

A name found as Tan in 682, Taan in 854, and Thon in 1243, this is a British or Celtic river name which describes 'the roaring stream'. This, as with many short and simple hill and river names, can be seen to be related to others in the Indo-European languages and theoretically directly from that mother tongue. Evidence for this is seen in the Gaulish river name Tanarus, an Italian river also known in Latin as Tonare.

TREBOROUGH

A name derived from Old English *treow beorg* and listed as Traberge in 1086, this began life as 'the hill or mound growing with trees'.

TRULL

While there are no surviving records of this name before 1225 as Trendle, the name itself tells us this is much older. Here Old English *trendel* describes the 'circular feature' which would have existed before the Romans departed in the fifth century.

TWERTON

A name found in Domesday as Twertone, in 1225 as Twyuerton and as Twiverton in 1236. This is from Old English and describes 'the *tun* or famstead at the double ford'; although there are no surviving records to confirm, there can be no doubt this is how the name developed.

Street names around here include several named after religious representatives. Shaws Way is named after the Reverend William Stokes Shaw, who was vicar of St Michael's from 1876-1904. Walwyn Close remembers the Reverend Bernard W. Shepheard Walwyn, who was vicar between 1919 and 1931. Many years earlier, Gilbert Newton was vicar 1529-60; he is commemorated by the naming of Newton Road.

Carr House stands in Woodhouse Road; the building was originally made from wood and was named such from the Carr family who lived there. Brunel House remembers Isambard Kingdom Brunel, the man who brought the railway to Twerton. Kelston View still affords excellent views of the village of that name. Alec Ricketts Close is named after Alderman Ricketts, who served as mayor of Bath. Former councillor Raymond Charles Rosewarn, who served the community from 1965, is remembered by Rosewarn Close.

Garrick Road remembers one of England's most acclaimed actors, David Garrick (1717-79). Sir Edwin Landseer (1802-73) is one of the nation's most celebrated painters, particularly when the subjects are animals, however, he is best known for sculpting the lions in Trafalgar Square and was the inspiration for the name of Landseer Road. Josiah Wedgwood (1707-54), the famous potter, is remembered by the naming of Wedgwood Road.

Day Crescent commemorates the life and work of Joseph Day, pioneer of the two-stroke engine. After studying engineering in London, he went to work for Stothert & Pitt in Bath and later went into business for himself. From 1878, his iron foundry was making cranes, mortar mills, compressors, and an assortment of other items, and it was here he developed the new engine. His company were general engineers, the production of engines little more than a sideline, most of these being used for motorcycles and boats. This lack of direction in business was reflected in the profits, which fluctuated wildly.

Sheridan Road is named after Irish-born playwright Richard Sheridan, who settled in Bath with his family in 1771. Following the publication of a newspaper article written by Captain Thomas Matthews, a character assassination on Elizabeth Linley (1754-92) to whom Sheridan was betrothed, Sheridan challenged him to a duel, firstly to be held in Hyde Park, then near Covent Garden, and finally, in 1772, a bloody and vicious encounter took place in Bath. Both men broke their swords and Matthews used the hilt as a bludgeon to pound Sheridan's face to resemble jelly. Cut and bloody, Sheridan was hospitalised but was pronounced out of danger eight days later. The couple did marry and the bride gave her name to Linley Close.

However, surely one of the best street names in the whole county is Freeview Road, nothing to do with television but a place where spectators could view the game being played at the home of Bath City Football Club without paying at the turnstile.

The Centurion Inn invariably refers to the Roman soldier, although the name has been used for many articles of war.

Chapter 20

Ubley–Vobster

UBLEY

A name found as Hubbanlege in the late tenth century and as Tumbeli in 1086. The existence of the initial 'T' in Domesday can be explained, for many will have been described as *atte* and when this was followed by a vowel the 't' sound stopped being at the end of one word and appeared at the beginning of the other. Here the Saxon personal name is followed by Old English *leah* and describes 'Ubba's woodland clearing'.

The local pub is the Dolphin, a creature greatly admired by seamen and considered their best friend. Indeed, ancient sailors thought the dolphin would entwine itself around the ship's anchor in a storm to prevent drifting. It was inevitable that the creature would be used to adorn the sign at the inn frequented or run by retired mariners.

UPHILL

Here is a name found as Opopille in Domesday, a somewhat unusual Old French phonetic version of the Saxon or Old English *uppan pyll*. It was almost inveitable that the modern form should have suggested a hill, however, the original meaning could not be more different, for this refers to 'the upper creek'.

UPTON

The earliest surviving record of this name is dated 1225 and is exactly as the modern form. This is as simple as it seems and comes from Old English *upp tun* and describes 'the higher farmstead'.

UPTON NOBLE

Records of Optone in Domesday and as Upton le Noble in 1291, here is 'the higher farmstead' which was a possession of Sir John le Noble by the thirteenth century. For a short time in the fourteenth century the place was known as Upton Caboche, presumably a temporary lord of the manor.

VOBSTER

Found as Fobbestor in 1234, this name comes from a Saxon personal name and Old English *torr*, which tells us of 'Fobb's rocky hill'.

Chapter 21

Walton–Writhlington

WALTON

Listed as Waltone in 1086 and as the modern form as early as 1196. This is from Old English *weald tun* or 'the farmstead near a wall'.

Locally we find Asney, a name describing 'the island or dry land in marsh where as trees grow'.

WALTON IN GORDANO

Found in Domesday as Waltona, this is of Old English origin and is either from *weald tun*, 'the farmstead in a forest', or *weall tun*, 'the farmstead with a wall'. This addition is an old district name and comes from *gor denu*, which is 'the muddy valley'.

WAMBROOK

This name is first found in a document dated 1280, exactly as it appears today. This comes from Old English *woh broc* and describes the '(place at) the winding brook'.

WANSDYKE

What is now a district name began as the name of an ancient embankment which overlooked the area now bearing its name. Found in a document dated 903 as Wodnes dic this name tells us the hill fort was considered of great importance to the inhabitants as 'the heathen god Woden's dyke', the war god's name followed by Old English *dic*.

WANSTROW

Seen in Domesday as Wandestreu, this name features a Saxon personal name and Old English *treow* and speaks of 'the tree of a man called Wand or Wandel'.

Around here we find the name of Cloford, listed as a separate community in Domesday as Cladforda and Claford, while by 1150 it had become Clatford and by 1327 Cloforde. This name is derived from Old English *clat ford*, describing 'the ford where burdocks grow'.

WASHFORD

First seen in a document dated 960 as Wecetford, this tells travellers they were at the 'ford on the road to Watchet'. A name which also tells us this place cannot have been here before the settlement at Watchet.

WATCHET

As stated in the previous entry this name must be older, however, the earliest surviving record is from two years after in 962 as Waecet and later as Wacet in Domesday. The origins are uncertain but it likely refers to a Celtic *ced* and tells of 'the lower wood'.

Here customers at the Valiant Soldier Inn, a term which is most often used to describe those who fought in the English Civil War, but could equally describe anyone who fought at the front. The Clipper Inn remembers the sailing ships which were the pinnacle of design, the fastest thing on the sea until steam power became more efficient.

Alongside the harbour at Watchet stand two statues, the largest marks the time spent in the coastal town by Samuel Taylor Coleridge, where he was said to have been inspired to write *The Rime of the Ancient Mariner*. While the fictional mariner has his back to the sea, the smaller statue quite rightly faces out toward the Irish Sea. This is John Short, better known as Yankee Jack, who was born here in 1839. He joined his father in trading along the coast at the age of fourteen but four years later headed out on his own to explore the ocean proper and travelled the world; he saw the Mediterranean, Australia, Canada, and Bombay, sailing East Indiamen, schooners and even steam-assisted vessels, while during the American Civil War, he was aboard North American vessels which earned him the sobriquet Yankee Jack.

He is best remembered as a shantyman, his art developed with shantying, which was not what we know today prior to the late nineteenth century. In 1914, he retired from his voyages to return to Watchet and care for his ailing wife. It was here he met Cecil Sharp who already had a reputation for collecting English folk songs. John Short gave him fifty shanties, forming a large part of the published collection, featuring any theme which would produce a pace to which the seamen could pull and heave. This covered cotton workers, tales from the heart, lust, storytelling, myths and reputations; anything was considered fair game for John Short, the shantyman. Sir Richard Terry later visited the man who had also seen life as the Town Crier and leading the local fire brigade. Without John Short and his two author friends, many of the sea shanties would have been lost – maybe we would never have known *Rio Grande*, *Shenandoah*, *Blow the Man Down*, *A Roving* or *Spanish Ladies*.

This son of Watchet was a favourite of the local historian, author, and former curator of the museum Ben Norman and this statue was his project. Sadly, Ben died two months before the statue was unveiled by his widow Margaret. The statue is as much a monument to Ben Norman as to Yankee Jack, who died at the grand old age of ninety-four.

Yankee Jack at Watchet

For Samuel Taylor Coleridge, who spent time in Watchet where he was inspired to write *The Rime of the Ancient Mariner*

WAYFORD

This name is first seen in 1206 as Watford, a name which comes from Old English *weg ford* and describes 'the ford on the way or road'.

WEARE

Found in Domesday as Werre and derived from Old English *wer*, this name speaks of 'the weir or fishing enclosure'. This gives an image of wicker fences or gates trapping fish to await capture for the table, fish being a much larger part of the diet in Saxon England. Indeed, there is a record of protesting servants being granted the rights to refuse to be fed salmon more than three times each week – how times have changed.

Here is the hamlet of Alston Sutton, a name referring to 'Aethelnoth's farmstead'.

WEDMORE

A name which comes from Old English *waethe mor* and describes 'the marshland where hunting took place'. This may well be telling us that the marshland was used to manipulate the hunt; the animal would take the fastest route of escape, which would also be the driest, enabling a trap to be set. The name is recorded as Wethnor in the ninth century and as Wedmore in 1086.

Here we find the hamlet of Bagley. Recorded as Bagelie, Bagalaia and Baggelega in the eleventh and twelfth centuries, this most likely comes from Old English for 'Bacga's woodland clearing'.

The Trotter Inn is named after the gait of the pony depicted on its sign, there being a long association between the horse and pub, and this is a refreshingly different way to depict it.

WELLINGTON

Recorded as Weolingtun in 904 and as Walintone in 1086, this name is derived from a Saxon personal name and Old English *ing tun* to tell us it was 'the farmstead associated with a man called Weola'.

The Holywell Inn has been a pub since the seventeenth century, although the well and an earlier building may date from the fourteenth century. The Weavers Arms is the longest continuously documented city guild, linked to the pub through a former landlord or owner. The Three Cups is a sign found since the sixteenth century, representing the Worshipful Company of Salters who produced and sold sea salt. The Martlet is another heraldic symbol: it is the imaginary bird which has no legs, representative of the fourth son of a family and suggesting that no land will come to him. The Blue Ball Inn reminds us of the Courtenay family, earls of Devon. The product is always a good subject for a sign, and thus a name, hence the name of the Vintage Inn and the Barley Mow.

The name of Champford Lane is a corruption of Sampford Lane, a destination name. Pound Lane here takes the name of the Pound House, where cider was made.

Sportsmans Arms, Wellington

Corams Lane remembers one of Wellington's most influential families. Rack Close was where wooden racks were seen, used to stretch and dry woollen cloth. Beacon Lane leads to Monument Hill, a place where signal fires were once set to report important news. Gallows Field is a corruption of the dialect word 'gallitraps', used to describe the circles seen in the grass caused by a fungus underground. Thus unseen, the rings were attributed to fairies or pixies and locally it was said that anyone found treading in such a ring would end up hanging from the gallows.

However, the most unsual street name has no known etymology. Mantle Street has been around since at least the late seventeenth century, a time when there were a surprising number of court cases regarding the poor workmanship in some of the houses of the town resulting in falling plasterwork and substandard 'Mantells'. The mantel was the heavy wooden piece which went across the fireplace and helped to spread the load from the chimney which would otherwise have found a weak spot in the grate. Could it be that this shoddy workmanship achieved a notoriety leading to the name of the houses and eventually the street?

WELLOW

The earliest surviving record dates from 1084 as Weleuue, which can only have been the original name of the stream here and a Celtic term meaning 'winding'.

Here the local pub unites two iconic images of the English countryside; the Fox & Badger also satisfies the apparent need to link two items with '&' for it to appear to be a pub name.

WELLS

We hardly need the records of Willan from 1050 and that of Welle in 1086 to see this is from Old English *wella* to describe 'the springs'.

The Fountain Inn may be heraldic, representing the Master Mariners or Company of Plumbers but, considering the meaning of the name of the city, most likely refers to the local spring. The Globe Inn represents a simple image and also hints that all are welcome, while the Kings Head refers to the monarchy in general, and the scenic splendour to the north-west is marked by the name of the Cheddar Valley Inn.

The streets of this small city have their own tale to tell. What was changed to Union Street in the middle of the nineteenth century had formerly been Grope Street, a name which tells us it was narrow and poorly lit, hence pedestrians having to grope their way along in the dark. Priest Row was probably named after the thirteenth-century priest who lived here. Vicar's Close was named after another cleric, Thomas de Devnysche, who bequeathed this land to the city for development in his fourteenth-century will. Wet Lane no longer exists, for it is now called Broad Street, although on the day the author visited, both names were equally appropriate.

Ash Lane took its name from the ash trees which grew around here. Chamberlain Street was named after the official who decided to clean up what had previously been, both in name and in actuality, Beggar Street. Market Street also enjoyed a change of name from Mede Street, the former name showing this had previously been the back way into the centre, while the present version is self-explanatory. Moniers Lane is named after the respected Peter le Monier, a moneyer who plied his 'trade' between Dartmouth, Exeter, Wells and Bristol and everywhere in between during the thirteenth century. Sadler Street remembers John Sadler, a fifteenth-century merchant who received a 'necessary pardon' after the Wars of the Roses, for he had backed the losing side but his worth to the city saved him. Tucker Street shows cloth making was here from an early time, for this was an early alternative name for a weaver.

Of course, the city has a long association with the church and the streets also reflect this. The cathedral is dedicated to St Andrew; founded in 705, the present building dates from 1180. The name was transferred to St Andrews Street. St Cuthbert Street takes its name from the church, this being the third building dedicated to St Cuthbert, and dates from the thirteenth century. St Thomas Street leads to the church built by Teulon, the architect being hired by Dean Jenkyns to cater for the poor of the parish. Sadly, the benefactor did not live to see the beginning of the work which was completed in three years. Furthermore, neither did his widow, Troth Jenkyns, who also died before the church opened to parishoners, from a chill she caught during the ceremony of laying the foundation stone.

WEMBDON

A name found in Domesday as Wademendune in Domesday, this comes from Old English *waethe mann dun* and describes 'the hill of the huntsmen'.

The rural location is also seen in the name of the Cottage Inn.

Left: Cathedral Entrance, Wells

Below: Henderson Place, Wells

Wells welcome sign

Priest Row, Wells, named after Nicholas
the priest

WEST BRADLEY

Found as Bradelega in 1196, this name is a common one and always refers to the 'broad woodland clearing' from Old English *brad leah*.

Within this parish we find the hamlet of Lottisham, seen as the modern form as early as 744 and meaning 'the homestead of a man known as Lott'. It is likely this is a nickname, for the Old English *lot* describes someone who is 'deceitful, vile'.

WEST BUCKLAND

Found as Bocland in 904, this name comes from Old English *boc land* and refers to 'the land granted by charter'. This is a name only found in the south of the country, with the exception of one example in Lincolnshire which was probably transferred to there. While there must be some relevance to this only being found in the south of England, the reasons are unclear.

WESTBURY-SUB-MENDIP

Here the basic name tells us this is 'the western fortified place'. As this is a fairly common place name, the addition is to be expected, which here tells us it is 'below the Mendip Hills', a name discussed under that listing.

The Castle public house, West Coker

WEST HATCH

This name features the Old English *haecc*, 'a hatch gate' to a forest, or a 'floodgate' in a stream. Here the addition distinguishes it from Hatch Beauchamp, this name being recorded as Hache in 1201 and Westhache in 1243.

A rural location describes the expected clientele at the Farmers Arms.

WESTHAY

A name which is derived from Old English *west haga* 'the western enclosure'.

The local pub is the Bird in Hand, a reminder that whatever you have is better than what you wish you had or that someone else has, and what is on sale within can soon be yours!

WEST MONKTON

Listed in Domesday as Monechetone, this is from Old English *munuc tun*, 'the farmstead of the monks', with the additional West showing its relationship with regard to Monksilver. Locals drink in the pub named after the place, the Monkton Inn.

WESTON IN GORDANO

A name recorded as Westone in 1086, as Weston in Gordenlond in 1271, and as Weston in Gordene by 1343. Here is the common 'western *tun* or farmstead', this time with the addition of the old district name describing 'the muddy valley'.

WESTON SUPER MARE

Many of the most common place names in the land most often has an addition to distinguish it from others. Here the *west tun* or 'Western farmstead' was as far west as it could go, for it has acquired Latin *mare* or 'on the sea'. The name appears as Weston in 1230, while the modern form is seen as early as 1349.

The district of Oldmixon is recorded as Almixton in 1200 and as Eldemixne in 1202. Here is a name from Old English *mixen* referring to a 'dunghill', a word which is related to *midden*, and a place which was once one of at least two so named. The name of the hamlet of West Wick comes from *west wic*, 'the specialised farmstead to the west', where the speciality is most often dairy produce.

In this popular seaside resort, it is the traditional destination for daytrippers from the large conurbations of the Midlands looking to bring the family to the beach, hence the name of the Bucket & Spade, while other pubs take their names from every traditional source.

Local places and people are seen in the Borough Arms, Town Crier, Walnut Tree, and Off the Rails, while national figures are also represented by names such as the Charles Dickens Inn, while the Raglan Arms recalls the man who served as military secretary to the Duke of Wellington, one Fitzroy James Henry Somerset, 1st Baron Raglan.

The old Birnbeck Pier at Weston Super Mare

Trades and tradesmen were inspiration for the Woolpack Inn and the Lamplighters, royalty is seen in the Imperial Hotel and Windsor Castle, while the image at the Dragon Inn would have been heraldic, the colour showing which family was commemorated.

It is always a good idea to advertise the product, as seen on signs such as the Bottle Bar, the Jug & Bottle, and even the Night Jar Inn, even if the bird of the same name is suggested. Of course, the sea is not far away, and pub names reflect this in names such as the Captain's Cabin, the Roaring Forties is a name given by sailors to the strong winds between latitudes of 40 to 50 degrees north and particularly south of the equator. However, the Red Admiral does not represent the chief rank of the British Navy, this is the name of a butterfly and was given to the pub, formerly called the Prince of Wales, when a new landlord arrived with his collection of butterflies.

The old pier at the northern end of the town has the distinction of being the only pier in the country to link the mainland to an offshore island. Now closed to the public, the Birnbeck Pier was opened in 1867 and was tethered at both ends, making its construction more like a bridge than the pleasure piers elsewhere in the country. This construction led to problems of the main walkway oscillating when a marching band was present both on the opening day and again twenty years later, leading to a ban on marching thereafter.

Jetties on the west, later replaced by one to the north, side of the island allowed paddle steamers to bring day trippers in from both sides of the Bristol Channel. Until a fire on Boxing Day 1897 many visitors arriving by sea never left the pier, making use of the entertainments and eating houses here. With the advent of the new Grand Pier in 1904 the focus started to move south toward the rapidly expanding town. Today the signs of damage by engineering equipment in 1984 and the storms of 1990 have left their mark

and the pier is closed for safety reasons. However, the site has been purchased and soon development will make it the most desirable part of the town, just as it had been almost 150 years ago.

WESTONZOYLAND

Domesday records this place as simply Sowi in 1086, while it is not until 1245 that we see Westsowi. This thirteenth-century record shows it was being called 'the western manor of the estate called Sowi', which then distinguished this place from Middlezoy and before the addition of *land* or 'cultivated area'.

WEST PENNARD

This is an early place name, derived from either Celtic *penn garth* and 'the hill with a ridge' or perhaps this is *penn ardd* meaning 'the high hill'. Records of this name include Pengerd in 681 and as Pennarminstre in Domesday, when there is the additional Old English *mynster* or 'large church'.

Here we also find the hamlet of Coxbridge, probably from Old English *cocc brycg* and telling of 'the bridge frequented by wild birds', although the first element could just possibly be a personal name. However, there is no doubt as to the origins of Woodlands; this is 'the cultivated lands near or by the woods'.

One local pub is the Appletree; tree names are favoured by pubs for they are prominent signposts in the landscape. Indeed, the tree was the beginning of the pub sign, for in the days when many places would brew their own ale, many travellers would look for such places in order to partake of their hospitality for both themselves and their horse, should they have one. In order to advertise this, a sheaf of barley would be tied to the trunk of the tree, which would have been stripped of at least its lower branches to make it stand out even more. Such was known as an ale stake and was the beginnings of the modern pub sign and thus pub name.

WHATLEY

Domesday's record of Watelege points to Old English *hwaete leah* or 'the woodland clearing where wheat is grown'. From this original settlement also grew a Lower Whatley.

A local name here is Chantry, with a Saxon personal name followed by Old English *treow* and meaning 'the tree of a man called Ceawa'.

WHEDDON CROSS

A name which has only recently acquired the addition. The earliest record dates from 1243 as Wheteden, a name from Old English *hwaete denu* or 'the valley where wheat is grown'.

WHITCHURCH

A common place name which, as can still be seen, refers to 'the white church'. From Old English *hwit cirice*, this suggests the building was of stone, not wood as were many churches of the day. The earliest record of this name dates from 1065 as Hwitecirce.

WHITELACKINGTON

Derived from a Saxon personal name and Old English *ing tun*, this is the 'farmstead associated with a man called Wihtlac' and is listed as Wyslagentona in 1086 and as Wichtlakington in 1225.

Local names include Ashwell, which is derived from 'the spring or stream by the ash trees', and Atherstone, a name found in three places with three different meanings, here describing 'Aethelheard's farmstead'.

WHITESTAUNTON

Recorded as Stantune in 1086 and as Whitestainton as early as 1337, here is 'the farmstead on stony ground', from Old English *stan tun*. The later addition of 'white' describes the limestone quarries around here.

WICK ST LAWRENCE

A name found as simply Wike in 1225 and which is derived from Old English *wic*. This term refers to 'the specialised farmstead', on most occasions referring to a dairy farm but here there is no clue as to what that speciality may have been. However, the addition is clearly from the dedication of the local church.

One local pub is the Ebdon Arms, itself named after the Ebdon Road.

WIDCOMBE (NORTH AND SOUTH)

Two places separated by less than a mile and which must share a common origin. The earliest record is of Widecomb in 1303, a name which is Old English and either *wid cumb*, 'the wide valley', or from *withig cumb*, 'the valley of willows'.

WILLETT (RIVER)

Any river is the sum of the water from its tributaries, while this river seems to be a combination of two of the names of those tributaries. Recorded as Willite in 854, this seems to feature the Old English *wiell* meaning 'spring, stream' and yet this would not explain the existence of two syllables. Indeed, it also ignores the fact that few Saxon river names stand alone without a second element. Here the most likely is an unrecorded

and Celtic name for this river, although there is a chance that this represents Old High German *goz* 'fluid' or perhaps *giozo* 'running water'.

WILLITON

Found in 904 as Willetun and as Willetone in 1086, this name comes from 'the *tun* or farmstead on the River Willett'. The river name is discussed under its own entry.

The Royal Huntsman is a pub which reminds us it stands in the former royal hunting forest, while the Wyndham Arms remembers the family who have been influential in the West Country since the sixteenth century.

WINCANTON

Domesday records this name as Wincaletone, a place name referring to the '*winn tun* on the River Cale', where *winn* means 'white' and *tun* 'farmstead'. The river name is discussed under its own entry.

The local here is the Nog Inn, a play on the 'noggin', a small measure of spirits or the glass that holds it.

Ireson Lane is named after Nathaniel Ireson (1686-1769), who lived in the town from about 1726. A famous architect, he designed several local buildings which also bear his name and also reshaped the inside of the 1650 building known as The Dogs, which referred to two stone greyhounds which once stood on the gateposts outside. Gennes Grove was named to show the town was twinned with Genens in France. In 2002, Wincanton was twinned with the fictional town of Ankh-Morpork, from Terry Pratchett's *Discworld* novels, for there is a shop in the High Street selling collectors items relating to Pratchett's novels and in 2009 names from the fictional city were used for streets in Wincanton and thus we find Peach Pie Street and Treacle Mine Road.

WINFORD

Found as Wunfrod around 1000 and as Wenfrod in 1086, this name combines two Celtic elements, *winn frud*, and describes 'the white or bright stream'.

Locally is the name of Felton, a hamlet which has never been listed any differently from today. This is from Old English *feld tun* or 'the farmstead in or by the open land'. Note the modern 'field' and the Saxon *feld* are not quite the same thing. No neatly trimmed and interwoven hedgerows with a wooden gate allowing access, the *feld* was an area cleared for grazing but the borders were simply uncleared areas of woodland and undergrowth, although there may have been a wicker hatch or gate across the gap allowing movement in and out.

WINSCOMBE

This place name comes from a Saxon personal name and Old English *cumb* to describe 'the valley of a man called Wine'. Records include Winescumbe in 965 and Winescombe in Domesday.

Millers Inn, Wincanton

The church of St Peter & St Paul,
Wincanton

The Star pub takes advantage of an easily recognised sign, one which is simple to portray and also suggests a drink in the evening during the days when licensing hours were restricted.

WINSFORD

Recorded as Winesford in Domesday, this is a Saxon personal name and Old English *ford* and describes 'Wine's ford'.

WINSHAM

The record of this name from 1046 is as Winesham, exactly the same as seen in Domesday forty years later. This is a Saxon personal name with Old English *ham* or *hamm* and speaks of 'Wine's homestead' or 'Wine's hemmed-in corner of land'.

There is also the hamlet of Whatley here, which, like its namesake, also describes 'the woodland clearing where wheat grows'.

The Bell Inn is a simple image, widely recognised, and also showing the close association between the church and the village pub.

WITHAM FRIARY

A name recorded in Domesday as Witeham, this is 'the homestead of the councillor', from Old English *wita ham*. The addition is not seen before the sixteenth century and comes from Latin *fraeria* or 'guild'.

WITHIEL FLOREY

Records of this name include Withiglea in 737 and Wythele Flory in 1305. This is derived from Old English *withig leah* and tells us of 'the woodland clearing where willows grow'. The addition is manorial, the de Flury family being here by the thirteenth century.

WITHYCOMBE

From Old English *withig cumb*, this refers to 'the valley where willow trees grow' and is recorded as Widicumbe in Domesday.

WITHYPOOL

The continued theme of the willow tree, which must have found its ideal habitat in the wetlands of Somerset, is found in the origins of this place name. Listed in Domesday as Widepolle, this comes from Old English *withig pol* and describes 'the willow tree pool'.

WIVELISCOMBE

Found in 854 as Wifelescumb and as Wivelescome in 1086, this is derived from a Saxon personal name and Old English *cumb* and speaks of this as 'the valley of a man called Wifel'.

The local Courtyard Inn takes the name of its location, unusually that which is outside and not referring to the pub itself.

Streets around the town tell a lot about its history. The Croft was an estate built in the early nineteenth century by the Bouchers, a family of yeoman farmers who in later years saw some of their number become solicitors. On this estate was Croft Close, which in turn gave a name to Croft Way, a road which takes traffic away from the centre of the town and was constructed in 1980. Jews Lane leads to Jews Farm, a corruption of Le Jeu, the family who owned this land in the fifteenth century. Storey's Close remembers the Storey family, who lived in the town since at least the early sixteenth century. In 1648, Henry Storey established a charity for the benefit of the impoverished of the parish.

Jubilee Gardens is a modern name given to mark the Silver Jubilee of Queen Elizabeth II in 1977. Silver Street is not recorded before 1887, coincidentally the same year as Queen Victoria's Golden Jubilee, which probably suggests this was created as there was already an ancient route known as Golden Hill, itself probably referring to yellow flowers which were found here, cowslips being the most common. Richard Beadon Close was formerly known as Rack Close, a place where frames or racks were seen and used to dry woollen cloth by stretching across the frames and attaching the cloth by means of hooks known as tenterhooks – hence the phrase 'on tenterhooks', meaning to wait, usually impatiently. Such a name was probably thought inappropriate owing to its association with the instrument of torture and thus previous owners were looked at and it was decided the last clerical owner was the least controversial, Bishop Richard Beadon.

The Square, previously known as Market Place, is metaphorically if not actually the traditional hub of the community. Similarly, Town Hill was once High Street and, before that, Fore Street, which both suggest the 'primary street' rather than geographical position. A part of what is now South Street, itself self-explanatory, was once called the Gullet, which describes much the same as this now rather out-dated term for the digestive system and meaning exactly the same in 'a passageway, way through'. Rotton Row is a corruption of Routine Row, as seen in the census of 1861, a name which had existed for many years before to describe the route 'routinely taken (by churchgoers)'.

Parrick's Place is named after the former owner of the Temperance Hotel, the name telling no alcoholic beverages were served. Hartswell House was constructed near to the Harts Well, itself an old place name describing 'the stream frequented by harts', and which was once known as Waldron House and named after the family that included Clement Waldron (1826-1906), who was a keen and industrious local historian. While Ford Lane is of obvious origin, it was previously known as Frog Lane, which is often given as being named after the common amphibians. Doubtless the cold-blooded frogs gave a name to many, however, here is a possible example of another use of 'frog' to describe 'a link, join, bridge'. This use is seen when speaking of railway track, a button and loop fastening, some stringed instruments, and where two watercourses are artificially connected.

Wiveliscombe welcomes us quite wonderfully

WOOKEY

Most often referred to as Wookey Hole, this name is recorded as Woky in 1065 and is from *wocig*, an Old English term referring to a 'snare or trap for animals'. This undoubtedly refers to the practice of driving animals into the gorge where they were trapped and easily slaughtered. The additional *hol* means 'ravine'.

Here is the hamlet of Yarley, a name from Old English *gyrd leah* and describing 'the woodland clearing where spars or poles are obtained'.

The pheasant is an attractive bird, introduced by the tenth century by the late Romano-Britons and again by the Normans. A game bird which had died out in large parts of the country by the seventeenth century, being largely ignored until intoduced on shooting estates to satisfy the demand there from around 1830. It is widespread and the male or cock bird adorns the sign outside the Pheasant public house.

WOOLAVINGTON

First seen as Hunlauintone in Domesday, when the researchers recorded eleven cattle, thirteen horses, thirty-three pigs, and 151 sheep, this name is later found as Willaveton, Wulavinton, Willavynton and Wilavinton during the thirteenth century alone. This name features a Saxon personal name, which could be either 'the farmstead associated with the people of Hunlaf or Wiglaf'.

WOOLLARD

A place name with very few records, making definition very difficult. Indeed, we can only guess that this is a corruption of a name which began as 'the ford where wolves are seen' and which we would normally expect to become Wolford. Alternatively, perhaps this is a remnant of the Saxon name 'Wulfweard' and where the suffix, assuming there was one, has been lost.

WOOLVERTON

A name not recorded until 1996, when it appears as Wulfrinton. This features a Saxon personal name and Old English *ing tun* which together describe 'the farmstead of a man called Wulfhere'.

WOOTTON COURTENAY

A name found in Domesday as simply Otone, later appearing as Wotton in 1274, and as Wotton Courtenay in 1408. Here the basic name is from Old English *wudu tun* or 'the farmstead by the wood', with the addition from John de Courtney, who held this place until his death in 1274.

WORLE

Domesday's record is exactly as it appears today, a name from Old English *wor leah* and telling us this was 'the woodland clearing frequented by wood grouse'.

Local pubs include the Golden Lion, a heraldic image which represents Henry I or, more commonly, the Percy family, dukes of Northumberland. The Observatory here remembers the building which was firstly a Windmill, later was adapted as the observatory, and was then a private house.

WRANTAGE

The earliest surviving record is from 1199 as Wrentis, a name from Old English *wraena etisc* and describing 'the pasture for stallions'.

The Bridgwater & Taunton Canal passes close to the parish boundary, hence the name of the local pub, the Canal.

WRAXALL

With records of Werocosale in Domesday and as Wrokeshall in 1227, this name probably refers to 'the nook of land frequented by the buzzard (or other raptor)' from Old English *wrocc halh*. However, the possibility that the first element is a personal name or nickname should not be discounted.

WRINGTON

This features an earlier, or possibly alternative, name for the River Yeo. Thus this is 'the *tun* or farmstead on the Wring or winding river'. While Domesday records this name as Weritone, the earlier record from 926 was Wringtone!

WRITHLINGTON

With this found as Writelinctone in Domesday and later the thirteenth-century records of Writhelington and Writhlington, this name is from Old English *writh hlinc* and describes 'the hill with a thicket'.

Chapter 22

Yarlington–Yeovilton

YARLINGTON

Found in Domesday as Gerlincgetuna, this name features as Saxon personal name and Old English *inga tun* and tells us it was 'the farmstead of the family or followers of a man called Gerla'.

YATTON

Domesday lists this place as Iatune, from Old English *eg tun* this is 'the farmstead by a river'.

Local pubs include the Market Inn and Butchers Arms, recalling trading places; the Railway Inn and Bridge Inn are reminders of local landmarks; while the Prince of Orange is named after the man who would become William III of England (1688-1702).

YEOVIL

Records of Gifle in 880 and as Givele in 1086 show this to be from 'the place on the River Giff'. This is another early or alternative name for the River Yeo, a Celtic river name meaning 'the forked one'.

To find different names for the same river is not surprising. In times when travel was slow, few people would ever have seen more than one sizable river in their entire lives. Furthermore, rivers show different moods depending on the area through which it is flowing and thus, as river names are invariably descriptions of the river, it could easily be given different names depending upon where it was being described.

Here is the name of Houndstone, recorded in Domesday as Hundestone and referring to 'Hund's *tun* or farmstead'.

Pubs here include those reminding us of other landmarks such as the Railway Hotel and the Great Western, Cooper's Mill, the Armoury, and the Bell Inn is associated with the nearby church, the Red House Inn describes itself and the Picketty Witch is a corruption of the tree also known as the 'piked wych elm'.

The William Dampier is named after the seventeenth-century sea captain, author and scientist who was born in Somerset. The Quicksilver Mail reminds us of the mail coach which came through here as it ran between London and Devonport; it gets its name because of its breakneck speed, averaging ten miles per hour which is less than an unfit cyclist does today. The Fleur de Lys is heraldic and represents France, while the Yellow

Quicksilver Mail, Yeovil

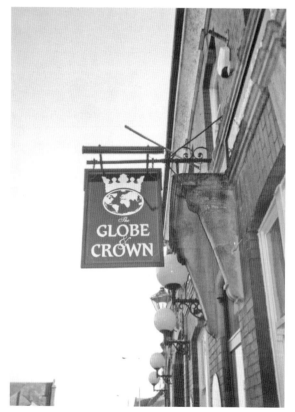

Above: Tabernacle Lane, Yeovil

Left: Globe and Crown Hotel, Yeovil

The Picketty Witch, Yeovil

Wagtail is a remnant of the time when Wadsworths Brewery named their houses after birds.

The Hole in the Wall is a name found across the land and has almost as many possible origins as there are examples. In more modern times, this was a term used for the first ATM machines, although it quickly fell out of use. In the past, it was used to refer to the hole in the cell of a condemned prisoner; the trap door which allowed innkeepers to pass a glass out to the coachman, the Georgian equivalent of the drive-thru; a way to feed lepers in the days when such patients were considered unclean and infectious; or even a narrow passageway leading to the pub itself.

Any town's streets tell a history of the place and yet, while many towns create names, surely few reflect the history of the place better than those found in Yeovil. Existing names are still favoured by developers and local authorities, Marl Close being originally a field name referring to its clay subsoil. Roping Road is an unusual variation on what is usually found as simply 'Rope' and refers to where these men and women toiled together to produce great lengths of rope the length of the street and more. The name of Middle Street is self-explanatory, however, it was previously called Fore Street, showing it was at the 'fore of the town' and of how the town has grown over the centuries.

Sparrow Road remembers the Sparrow family; the earliest known was John Sperwe, who was here by 1417. Matthews Road was another honour given to Jabes Matthews, already made a freeman of the borough. There used to be a Pashen's Court, named after George Pashen who preached at the tabernacle chapel, itself still found in the name of

Tabernacle Lane. Frederick Place stands where the builder's yard of Frederick Cox could once be found. John Beswick had a fishmonger's on the corner of the road which has since become known, rather unusually, to mark the man's source of supply as Grimsby Corner.

Colmer Road is named after the former physician Dr P. S. H. Colmer, who also found time to serve on local government and served as mayor from 1887 to 1889, and again from 1890 to 1892. Another mayor, W. R. E. Mitchelmore, served three consecutive terms from 1918 and has Mitchelmore Road named after him. Stiby Road remembers the mayor of 1904-5, Henry Stiby. Levi Beer developed several streets in Yeovil and also served as town councillor; a renowned character, he deserved the naming of Beer Street. Earle Street was named after another developer, Earle Tucker, who was related to another developer by marriage, Earle Vincent having Vincent Street named in his honour. Everton Road remembers Everton Watts, son of benefactor Sidney Watts, who gave his name to Sidney Gardens. Peter Daniell, son of benefactor William Daniell, gave his name to Peter Street.

Other families who did much for the town are also suitably honoured. Dampier Street features the name of the family who were earlier working Dampier's Farm, Thomas Dampier was here by 1842. However, the best known is William Dampier, whose name now adorns a public house which stands where his glove factory once provided a living for many locals. Glove Walk is another example of the Dampier factory influence. Similarly, Kiddles Lane remembers the owners of the leather dressing factory, the Kiddle family. Petter's Way remembers the family who, over successive generations, went from being ironmongers, to iron founders, oil engine manufacturers, and latterly worked in engine design and construction.

National figures are always a favourite theme when names are being sought. However, to name something after a living person means running the risk of them managing to get themselves remembered for the wrong reasons. The town has managed to avoid such by limiting the number of choices, hence we find Rosebery Lane after Lord Rosebery, former Liberal prime minister; Beaconsfield Terrace takes the title chosen by former prime minister Benjamin Disraeli; the old road of Salisbury Terrace remembers another prime minister, the Marquis of Salisbury, whose family name was Cecil and hence the name of Cecil Street; King George Street after George V; Alexandra Road after the consort of Edward VII; and Victoria Road and Victoria Close after the longest reigning English monarch to date.

Waterloo Road was named as it was developed shortly after the nation was finally sure it was safe from the threat of invasion by the French under Napoleon, since he had recently, quite literally, met his Waterloo.

Of course, the more recent history of Yeovil has been closely linked with the military and in particular since warfare took to the air. No surprise then to find the old training ground to have been developed with names such as Artillery Road, Armoury Road, and Limber Road. Lysander Road remembers the important missions flown by this Second World War aircraft, while Bofors Park is named from the light anti-aircraft gun of this name. Finally, we remember why we fought in Freedom Avenue, and also the victory in Wingate Avenue.

YEOVILTON

Identical with the previous name except for the addition of *tun* and thus 'the farmstead on the River Gilf'.

The hamlet of Speckington is recorded as Speketon in 1253, as Spekynton in 1281 and as Spekington in 1285. The first element here is almost certainly derived from Old English *spaec* and refers to 'dry twigs, brushwood'. However, the remainder of the name is *ing tun*, of which *ing* is the most telling, for it only follows a personal name. Thus this is 'the farmstead associated with a man called Twig', where the name is used as a personal name or nickname.

Common Place Name Elements

ELEMENT	ORIGIN	MEANING
ac	Old English	oak tree
banke	Old Scandinavian	bank, hill slope
bearu	Old English	grove, wood
bekkr	Old Scandinavian	stream
berg	Old Scandinavian	hill
birce	Old English	birch tree
brad	Old English	broad
broc	Old English	brook, stream
brycg	Old English	bridge
burh	Old English	fortified place
burna	Old English	stream
by	Old Scandinavian	farmstead
ceap	Old English	market
ceaster	Old English	Roman stronghold
cirice	Old English	church
clif	Old English	cliff, slope
cocc	Old English	woodcock
cot	Old English	cottage
cumb	Old English	valley
cweorn	Old English	quern
cyning	Old English	king
dael	Old English	valley
dalr	Old Scandinavian	valley
denu	Old English	valley
draeg	Old English	portage
dun	Old English	hill
ea	Old English	river
east	Old English	east
ecg	Old English	edge
eg	Old English	island
eorl	Old English	nobleman
eowestre	Old English	fold for sheep
fald	Old English	animal enclosure
feld	Old English	open land
ford	Old English	river crossing

ful	Old English	foul, dirty
geard	Old English	yard
geat	Old English	gap, pass
haeg	Old English	enclosure
haeth	Old English	heath
haga	Old English	hedged enclosure
halh	Old English	nook of land
ham	Old English	homestead
hamm	Old English	river meadow
heah	Old English	high, chief
hlaw	Old English	tumulus, mound
hoh	Old English	hill spur
hop	Old English	enclosed valley
hrycg	Old English	ridge
hwaete	Old English	wheat
hwit	Old English	white
hyll	Old English	hill
lacu	Old English	streamlet, water course
lang	Old English	long
langr	Old Scandinavian	long
leah	Old English	woodland clearing
lytel	Old English	little
meos	Old English	moss
mere	Old English	lake
middel	Old English	middle
mor	Old English	moorland
myln	Old English	mill
niwe	Old English	new
north	Old English	north
ofer	Old English	bank, ridge
penn	Old English	rocky hill
pol	Old English	pool, pond
preost	Old English	priest
ruh	Old English	rough
salh	Old English	willow
sceaga	Old English	small wood, copse
sceap	Old English	sheep
stan	Old English	stone, boundary stone
steinn	Old Scandinavian	stone, boundary stone
stapol	Old English	post, pillar
stoc	Old English	secondary or special settlement
stocc	Old English	stump, log
stow	Old English	assembly or holy place
straet	Old English	Roman road
suth	Old English	south
torr	Old English	rock hill or outcrop
thorp	Old Scandinavian	outlying farmstead

treow	Old English	tree, post
tun	Old English	farmstead
wald	Old English	woodland, forest
wella	Old English	spring, stream
west	Old English	west
wic	Old English	specialised, usually dairy farm
withig	Old English	willow tree
worth	Old English	an enclosure
wudu	Old English	wood

Bibliography

Oxford Dictionary of English Place Names by A. D. Mills
Scottish Place Names by George Mackay
Concise Oxford Dictionary of English Place Names by Eilert Ekwall
A Dictionary of Pub Names by Leslie Dunkling and Gordon Wright
The Book of Frome by Michael McGarvie
History of Twerton by Peter R. Little
Squibbs' History of Bridgwater by Philip J. Squibbs
Minehead: A New History by Hilary Binding and Douglas Stevens
Wells: A Small City by Tony Scrase
Shepton Mallett: A Town Trail by Fred Davis
The Book of Street by Michael McGarvie
A History of Stoke St Michael by Joyce Jefferson and Stoke History Group
Yeovil History in Street Names by Leslie Brooke
Bridgwater Town Trails by Bridgwater District Civic Society
Squibb's History of Bridgwater by Philip J. Squibbs
The History of Wellington by Arthur L. Humphreys
The Book of Frome by Michael McGarvie
Wifeliscombe: A History by Susan Maria Farrington

Also available from Amberley Publishing

Gloucestershire
Place Names

Anthony Poulton-Smith

ISBN: 978-1-84868-721-9

Price: £12.99

Available from all good bookshops, or order direct
from our website www.amberleybooks.com